D1202219

# PETE DINE

# ANIMALS ON WHITE

Texts by Markus Mäder

EDITION STEMMLE

Zurich New York

# Contents

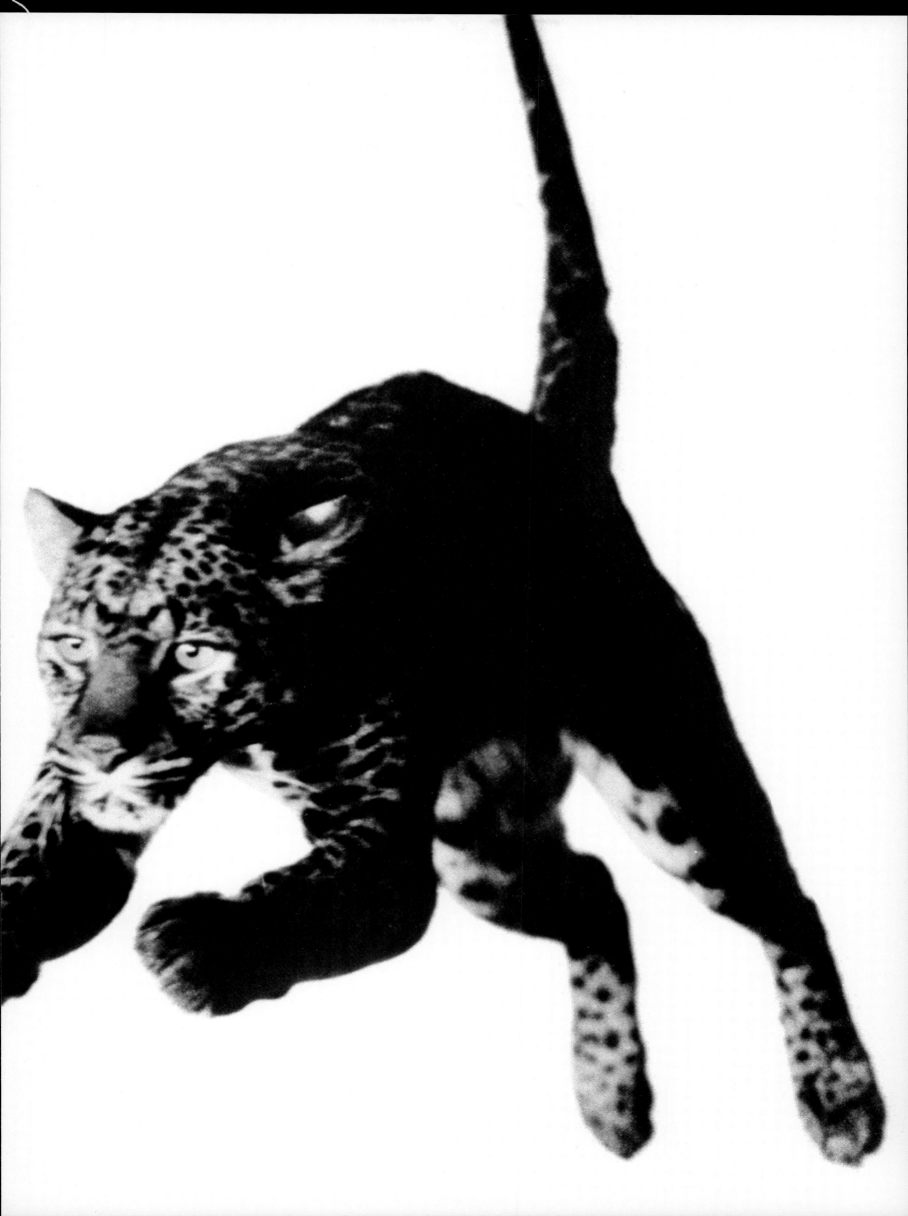

## "He Talks Their Language"

"He talks their language," he said in a hoarse, mysterious voice.

"The animals' language? " I cried.

"Why certainly, " said Matthew. "All animals have some kind of a language. Some sorts talk more than others; some only speak in sign language, like deaf-and-dumb. But the Doctor, he understands them all—birds as well as animals."

Dr. Dolittle is one such person, Francis of Assisi another, Mowgli in *Jungle Book* another. The animals speak to Pete Dine in their own particular way. On white. Divorced from the wilds, freed from their enclosures, they look like they did in Albrecht Dürer's time, five hundred years ago. They speak for their genus, their family, their species, and not least for themselves, with everything that "personally" characterizes them. They stand there a bit like stuffed specimens in classrooms and natural history museums, though now they are freshly washed and as close to life as is possible in one hundredth of a shutter second: the fox trotting in a straight line, the hare hobbling along, and all so precisely that the whole movement takes place before our inner eye.

**Why Is There No Sea-Horse Among Them?** Of the 40,000 vertebrates on this planet, half are fish living in water. Yet the abundance and diversity of the remaining 20,000 knows no bounds. So anyone who has to make a selection will—consciously or unconsciously—apply his or her own method. After all, there are animals and animals. Some we regard as more worthy than others.

It's as if Noah had watched carefully and in deference to our childish notion of "all living creatures and things" both on the ground and in the air. For one thing is sure, he too had to choose. What would you spontaneously decide to take with you on a ship over the waves to dry land? Animals from the world of your childhood, most likely. Animals you have always had a great liking for—which does not necessarily mean that those animals reciprocate that feeling. An ark must include animals that are indispensable. Pets and domestic animals, above all, those beasts of burden that carry us part of our way, or relieve us of some of our work or otherwise help us by guarding the house and farmyard, or gaining our affection. And those that have not quite made it to domestication yet are at least useful as prey. It is because these animals are close to us that they also populate our myths and fairytales. In our cultural circles, elephants, giraffes and lions are far from useful for keeping body and soul together.

This proximity has another side to it, one that has to do with the history of evolution. Neither Dr. Dolittle nor Saint Francis talked to the *drosophila melanogaster* (fruit fly). Myth presupposes that we ascribe thoughts and feelings to animals. Insects do not have that faithful look in their eyes, that warm paw. The least an animal must have is a vertebral column. The closer animals are related to us, the more directly they appeal to us; either because they suckle their young, or because they at least look after their brood, like birds. After all, it is this human aspect that goes to the heart, and like love, the way to the heart is through the stomach.

**Admittedly, We Don't Eat All Kinds of Animals** Of the animals on the following pages there are many that we love both alive and served up on a plate. And yet not every animal we consume—the snail, for example—would be welcome on the ark. On the other hand, we don't eat all the animals we don't like, and yet we still take them on board. For example, the raven, if only because it can reproduce human sounds, and is perhaps a bewitched prince. These gastronomic aspects are more complicated that they seem at first sight, and they can become so entangled with the love aspects that many a person is happier to live without meat. We can only speculate as to how Noah solved

that problem. How did predators like the lynx or fox merit their rescuer's consideration? Perhaps the bear did so because he spared his rescuer? Probably they had interviews with Noah. But where are the legendary beasts, the unicorn, the griffin or the behemoth? In his *A History of the World in 10½ Chapters,* Julian Barnes does away with all our childish notions: Noah and his clan gobbled them up—why else did he bring the animals along? And how does Barnes know? The woodworm told him; they were there, as stowaways. We will make do with the realization that it is always the victors who tell the story—and let a number of them file past, in all their pre-Fall innocence.

**Animals On White Don't Shed Their Coats**  They don't scratch the furniture, and their threatening gestures are restrained in the two-dimensional. There is no whiff of the stable to remind us of their other aspects. White is white. And they are all splendid samples of their kind. To this extent, they have something archetypal, something ideal about them. The animal we see lying there is an English greyhound, but not just that, it is also the very essence of a dog, one that has completely internalized its dogness. There is nothing doglike about a dog, nothing silly about an ass.

Keeping in mind the familiar patterns of biology that focus on differences in order to classify genus, family and species, we like to wonder at the diversity that still remains after Noah's feasting. When placed side by side, it almost seems as if God created "all living creatures and things" one after the other, in seven days. We examine the body of a species for barely visible features so as to enter yet another subspecies into nature's pattern book. That approach may be more than outdated, yet on white, it seems remarkably modern, even utopian. On white, a quasi-globalized ubiquity reigns supreme: When fox and hare, bear and parrot appear in the same size and in the same non-place, a living equivalence, an attitude of live and let live puts a surprising end to the all too familiar battle for survival. As creatures of the culture of the 21st century, we are all ears when it comes to the idea of one-world.

**We Have Something In Common**  All of us down here are made not of clay, but of DNA acid. The differences between man and animal are reduced to less than 2% of the genome. So little, that—like donkey and horse—we could, theoretically at least, mate primates. Yet animals remain animals, and the difference amounts to an insuperable barrier. Or do our animals see things differently? What would they say if they could put it in words?

Perhaps two parrots are talking to one another, and we are only peripheral participants. Perhaps. In the short time it takes to feel on familiar terms with them, the strangeness immediately makes itself felt. Their eyes, their gestures. How close they are to us. How far away from us they remain. You can put a cap on them or give them toys. The barrier remains. This white of infinite emptiness in which what we have in common disappears just beyond the body. Anyone who talks to animals tells us about our speechlessness.

*Markus Mäder*

**Baldinger Tiger** *(Sus scrofa)* Never again will a young piglet like this one wink at you out of the corner of its eye. Since this photo was taken the strain has died out—become extinct, like many other regional breeds. "Do we all finish up on a plate?" Babe asks her mother in the film of the same name. "Yes. All!" But the piglet nevertheless manages to escape his fate.

More successful than the Baldinger Tiger, the Belgian Pietrain is making inroads right round the world. Its big advantage is that it brings to the slaughterhouse a muscle-packed frame with little fat. When it's young, you would need a blood-test to distinguish it from its extinct relation.

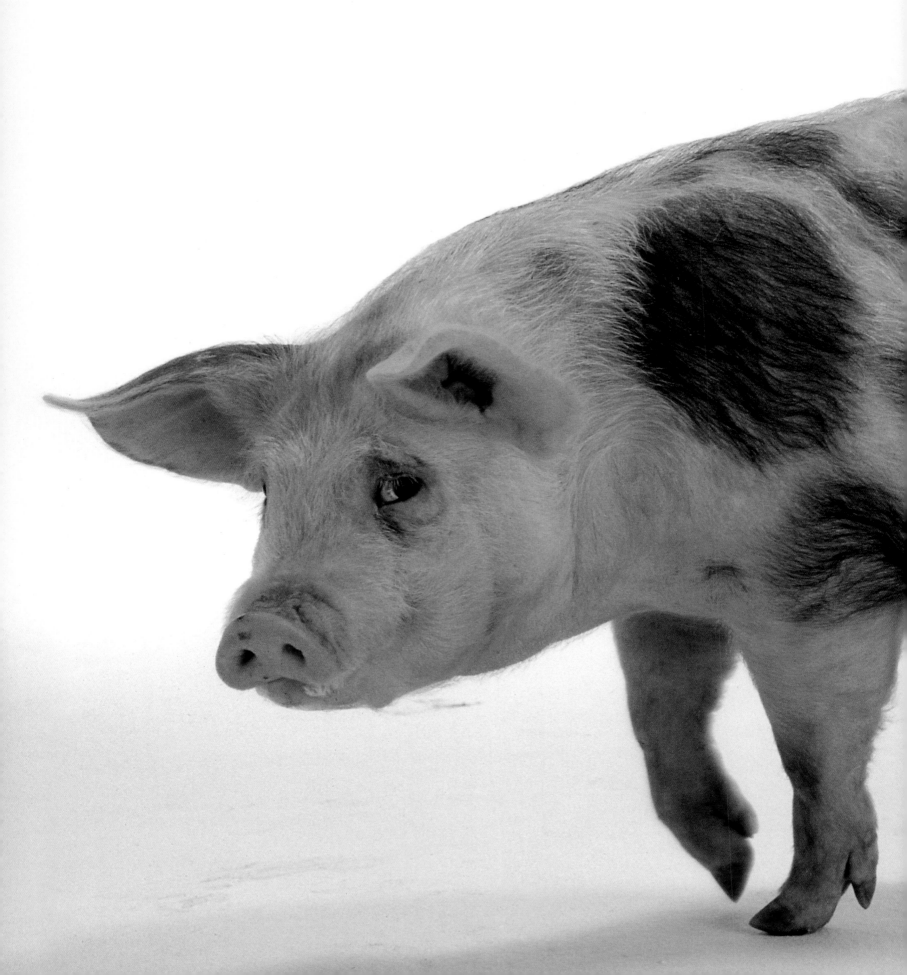

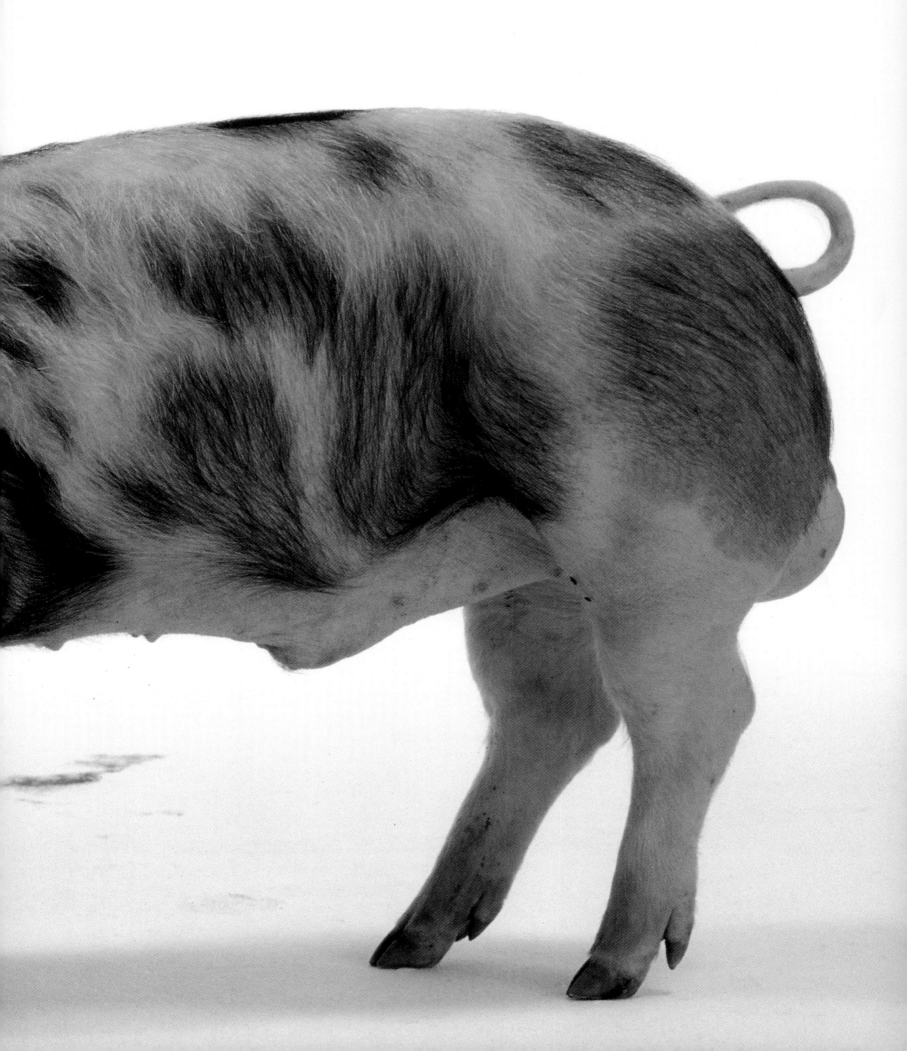

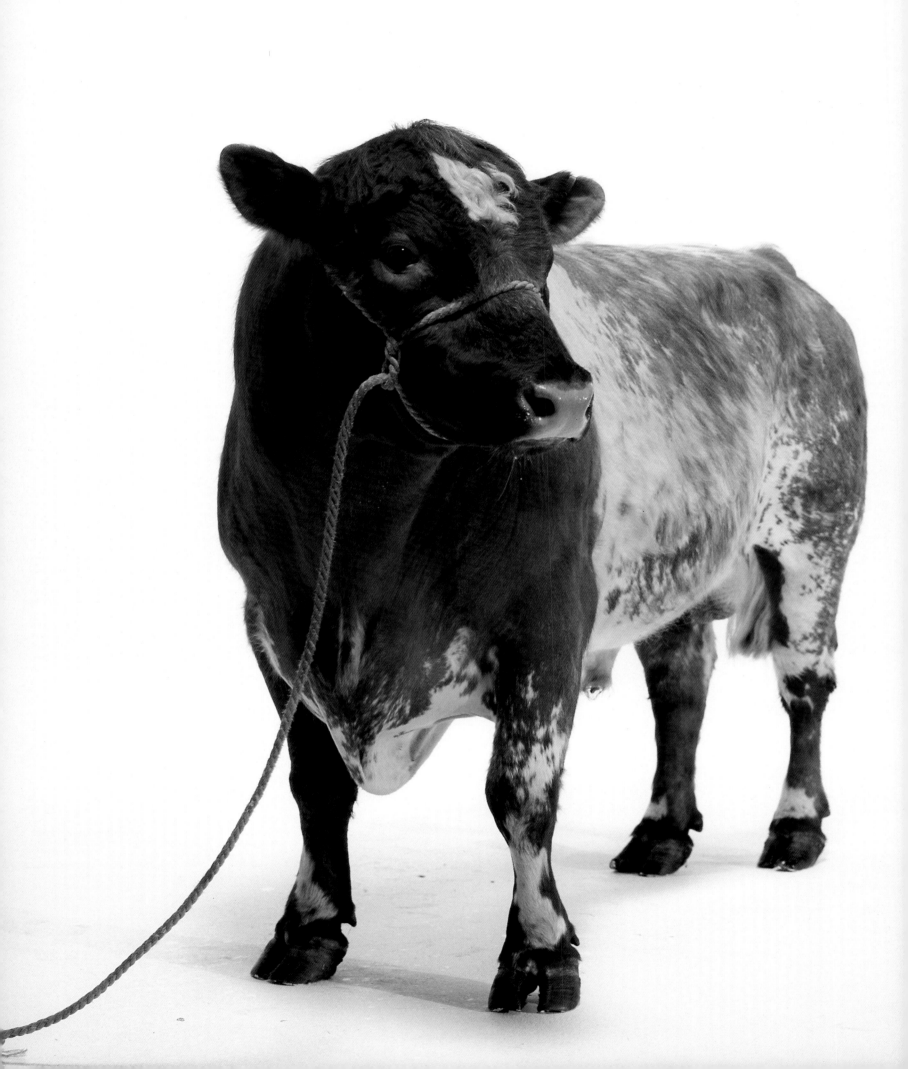

**Bull**  *(Bos primigenius f. taurus)*

**Charolais Bull** *(Bos primigenius f. taurus)* Whoever grows up in the shippon like him has got his shape not from exercise, but out of the deep-freeze in the Artificial Insemination station. Charolais cattle have been bred in France as fast-growing beef-cattle since 1773. This bull has long been slaughtered. His sperm—in a test tube—will still allow him to sire a couple of thousand offspring over several years: to the delectation of gourmets in five continents.

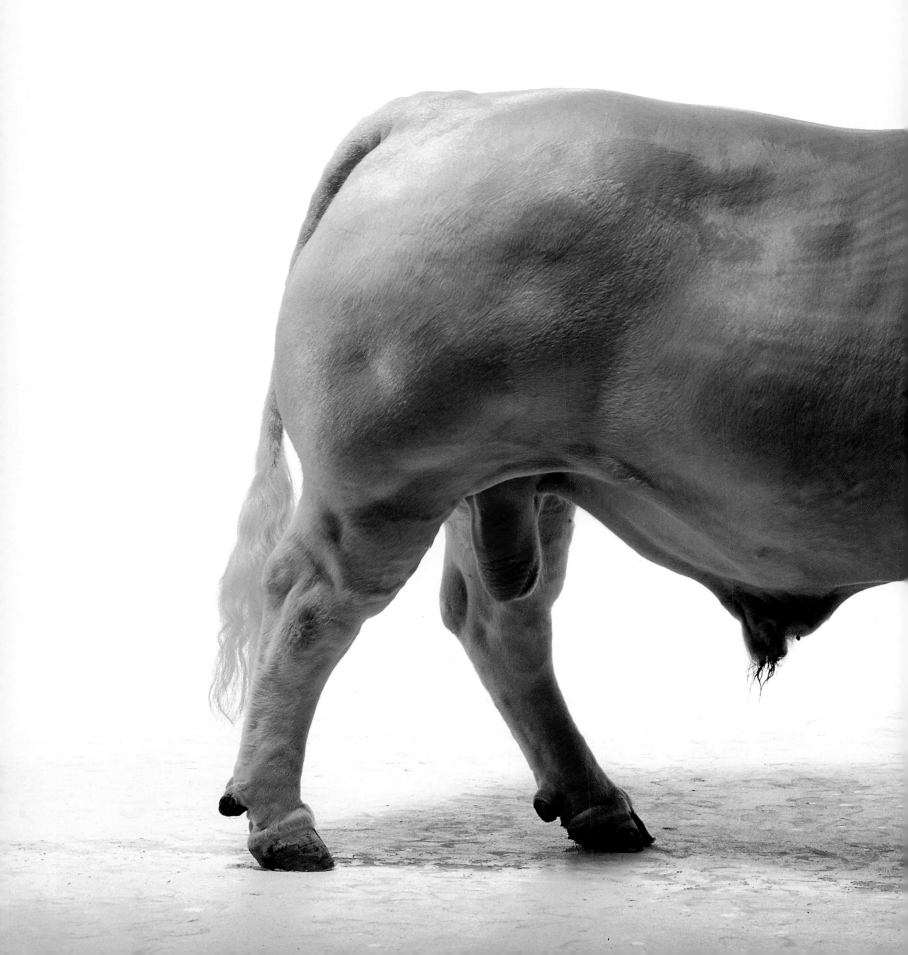

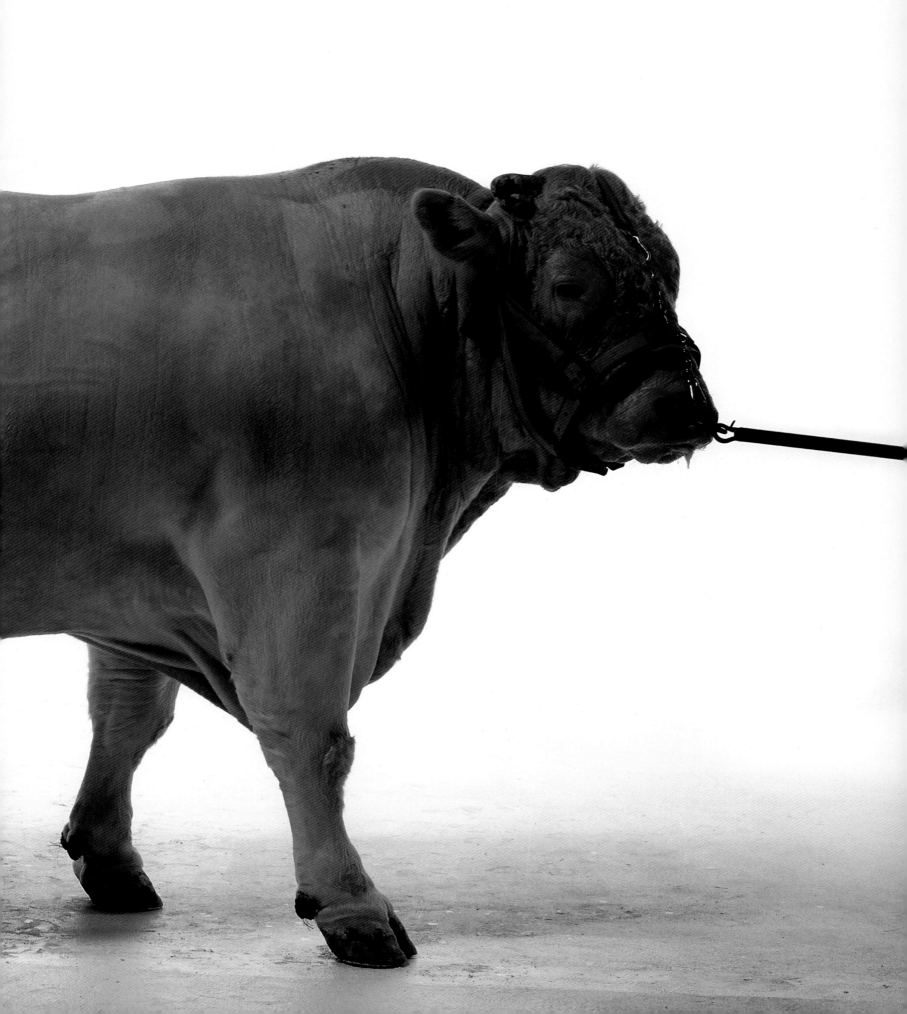

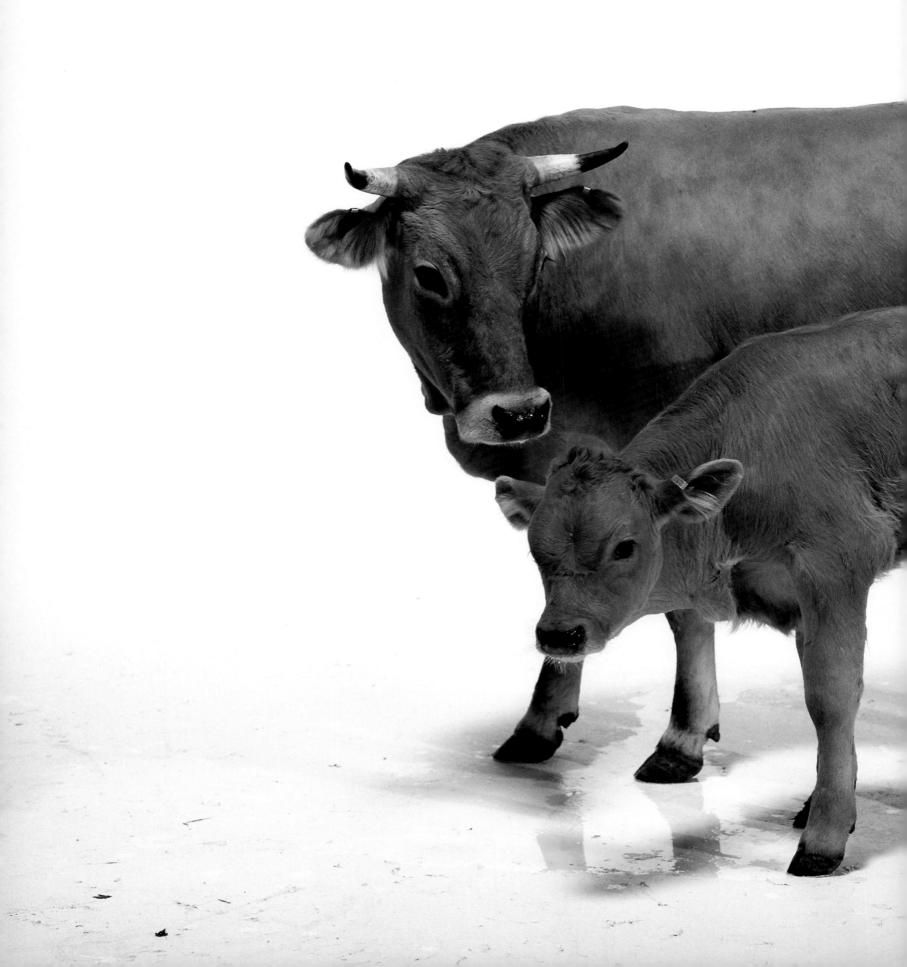

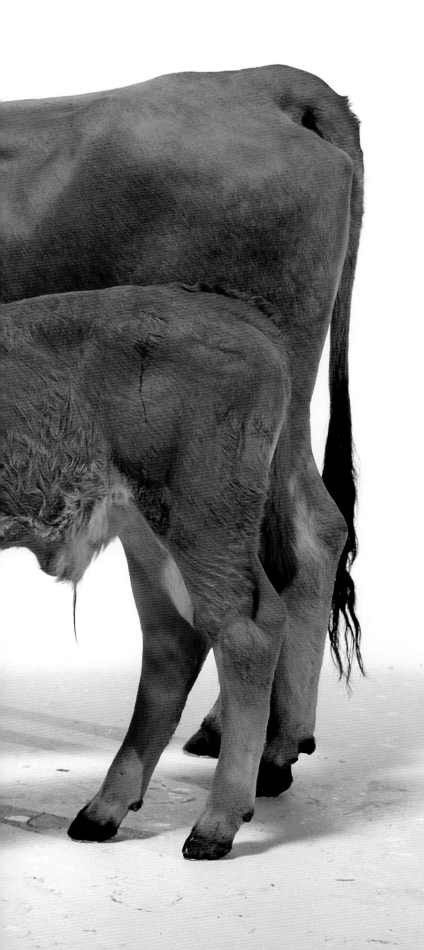

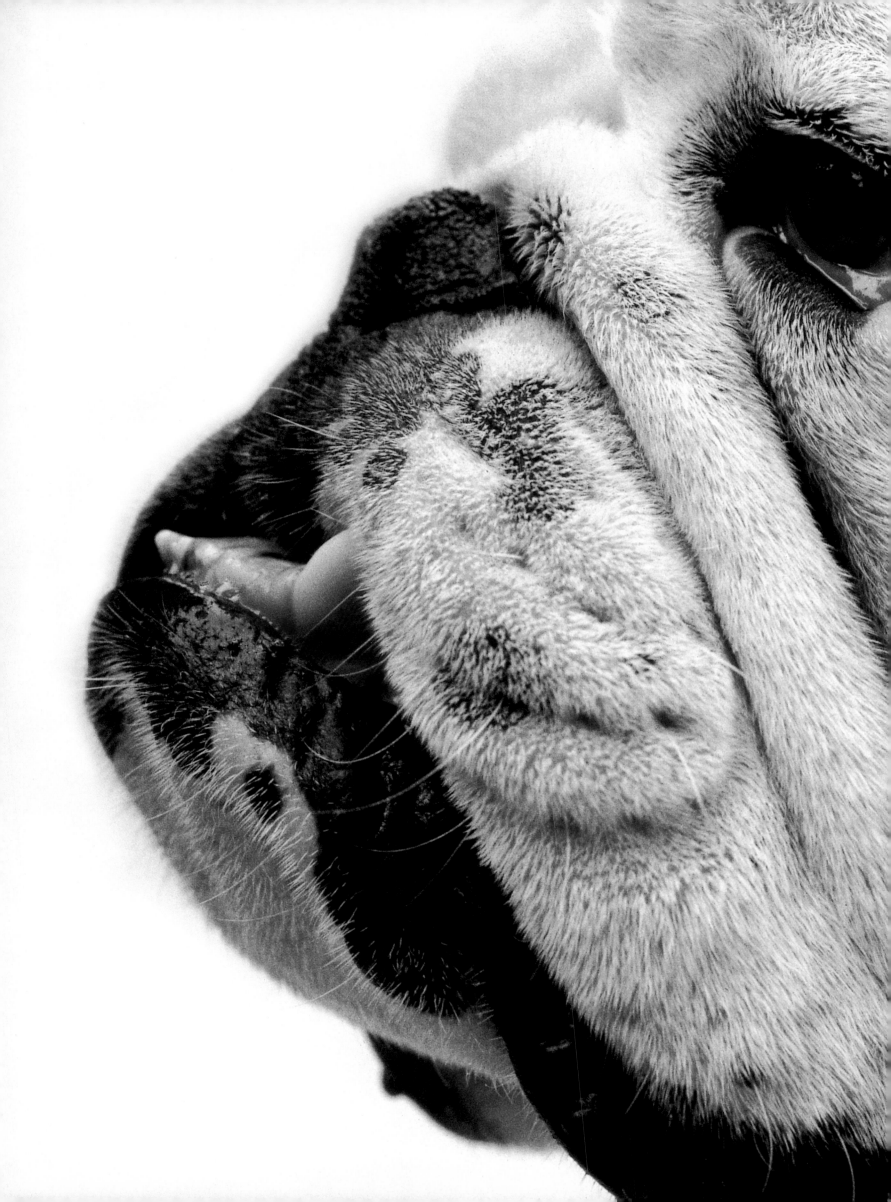

**English Bulldog** *(Canis familiaris)* Down, Carlo! Don't fool about with this little fellow! The prejudiced instinctively see in him the born criminal. He accepts that. He has a thick skin. This shows character—and a self-confidence for which fluffy pets can only envy him. Because Carlo is not just any old English bulldog. He is the one who scoops up all the prizes at international competitions. A champion in his rare class. A dog like this is worth his weight in gold. But Carlo is not for sale. Undying friendship is beyond price.

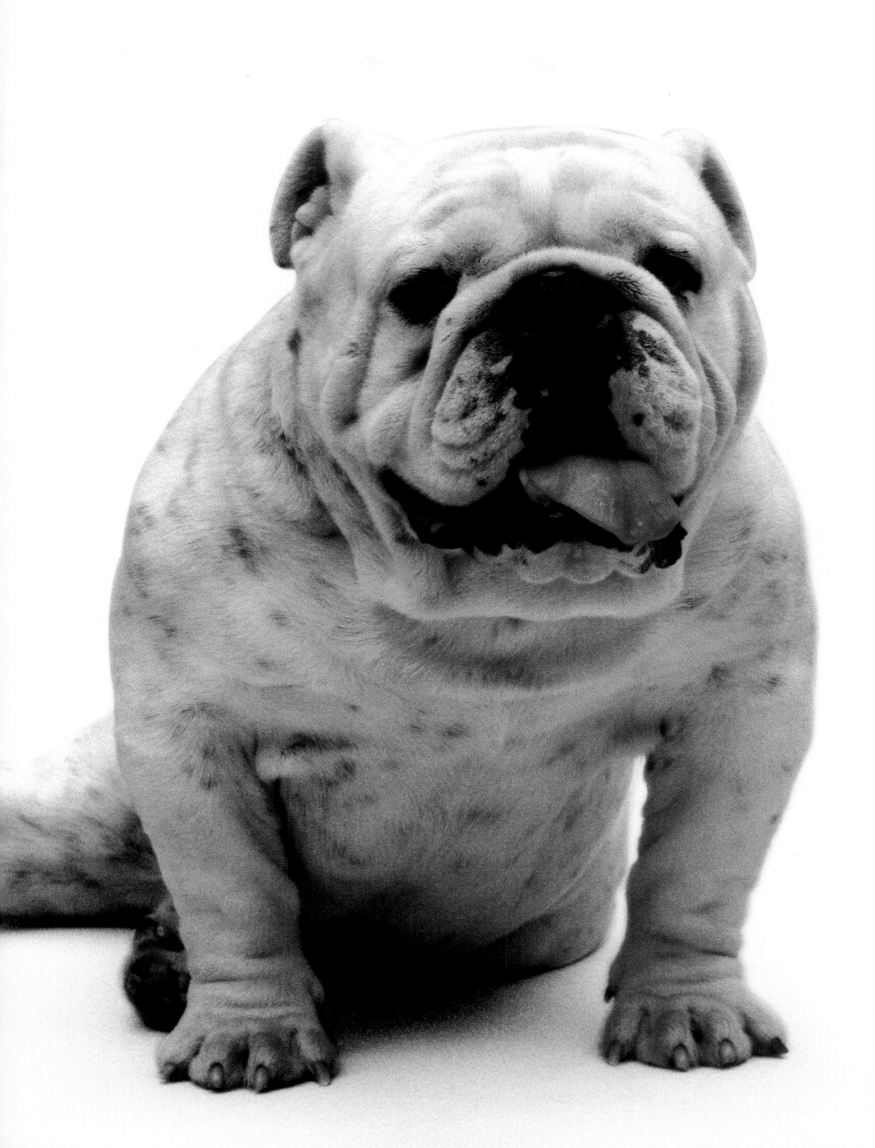

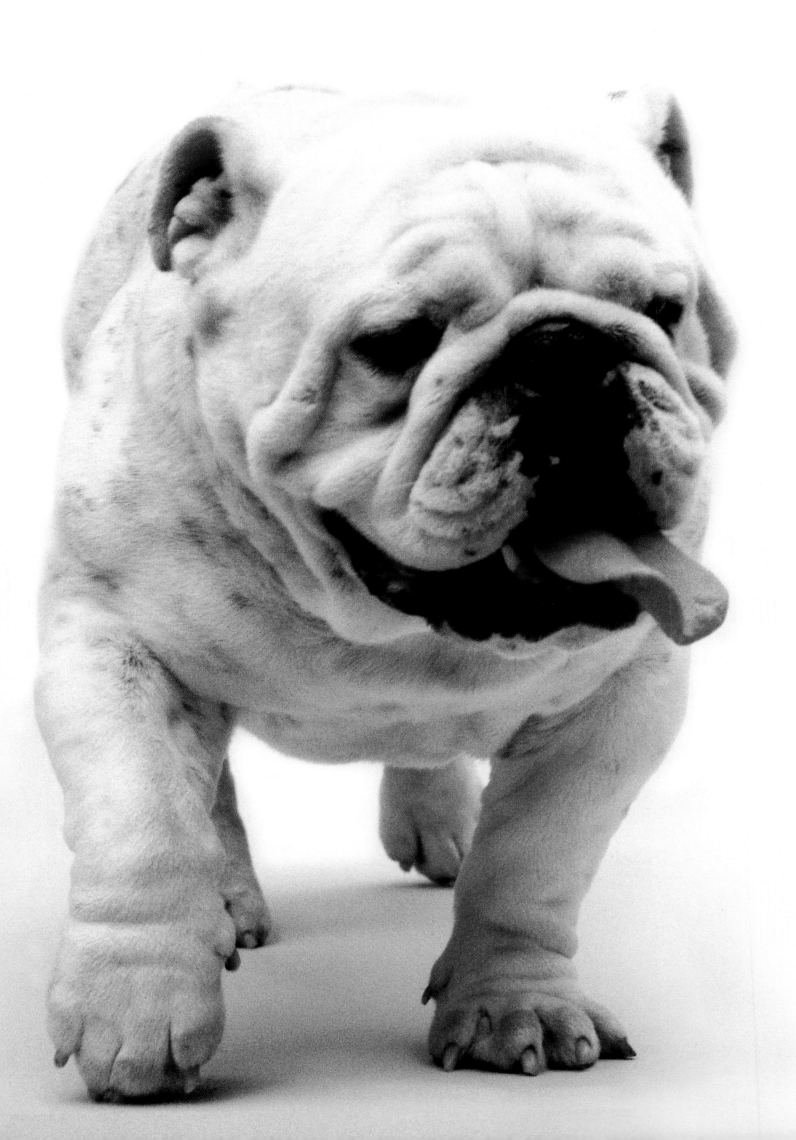

**English Bulldog**  *(Canis familiaris)*  He gets his name from the fact that he will fasten on to the hind legs of a bull and not let go. Still, since bull-baiting was outlawed in England in 1835 he has become somewhat gentler. His tongue is only hanging out because the lamps are making it hot. And he will get even hotter when the breeder parades a female in front of him. At the age of four and a half he has already fathered more than forty pups. What a litter, each time! But the mother often has a difficult birth. The large head of the whelps can block the birthcanal, necessitating a caesarian operation. But that's not anything to worry Carlo.

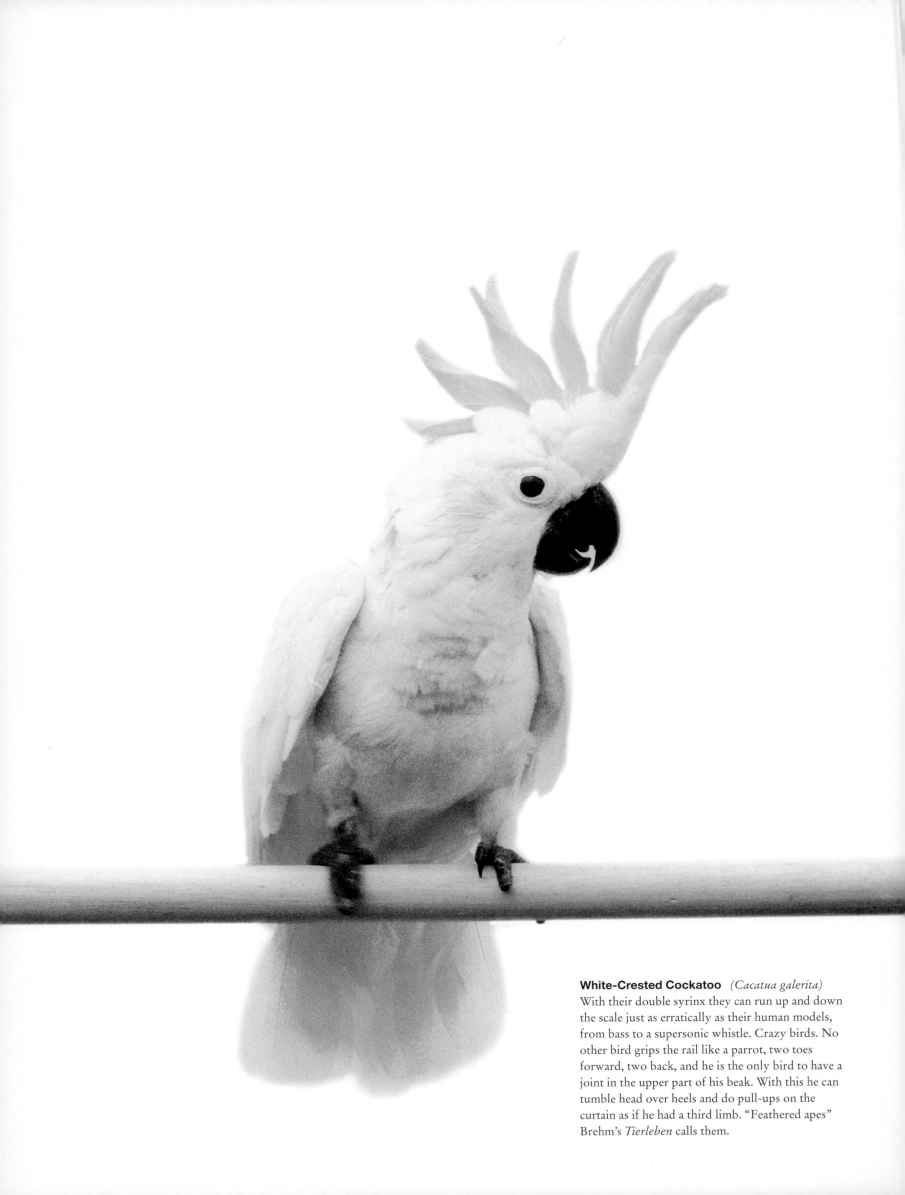

**White-Crested Cockatoo** *(Cacatua galerita)*
With their double syrinx they can run up and down
the scale just as erratically as their human models,
from bass to a supersonic whistle. Crazy birds. No
other bird grips the rail like a parrot, two toes
forward, two back, and he is the only bird to have a
joint in the upper part of his beak. With this he can
tumble head over heels and do pull-ups on the
curtain as if he had a third limb. "Feathered apes"
Brehm's *Tierleben* calls them.

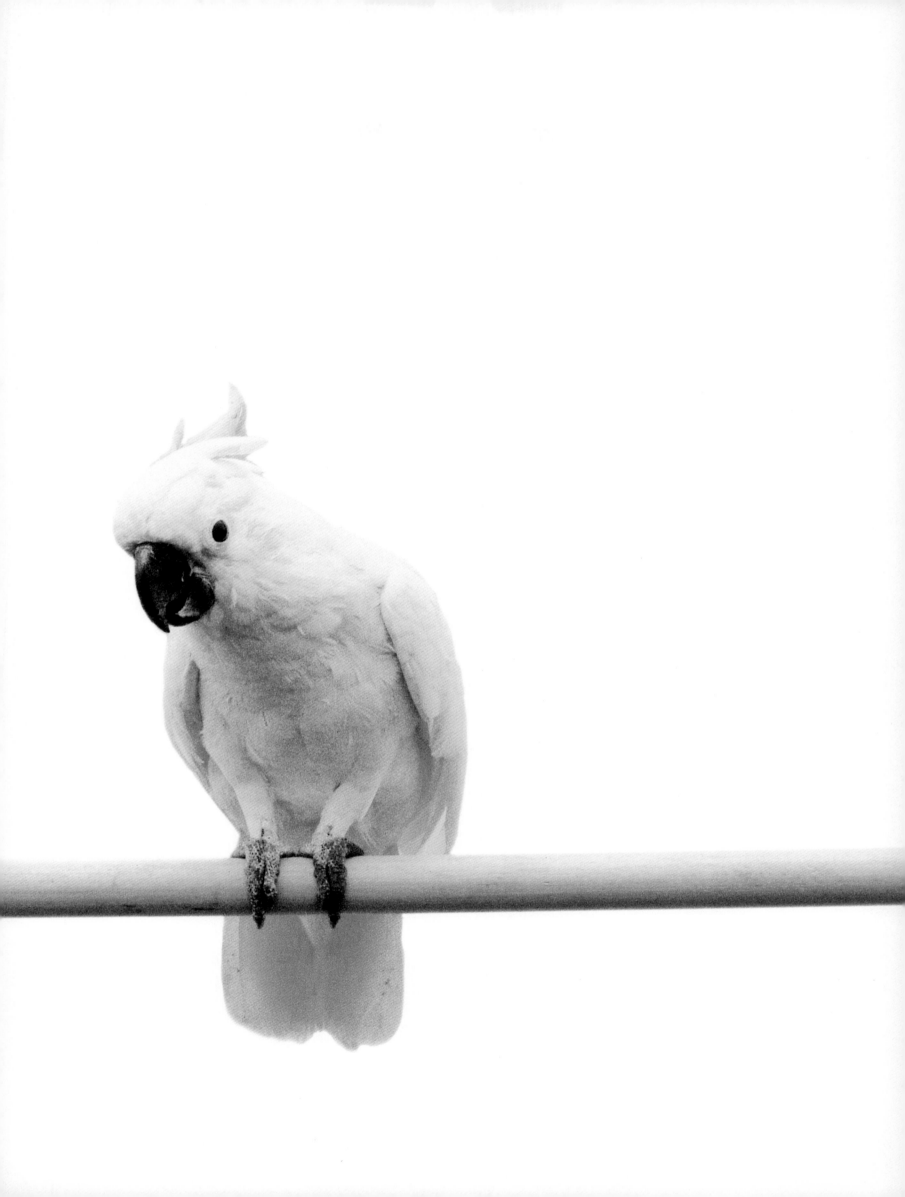

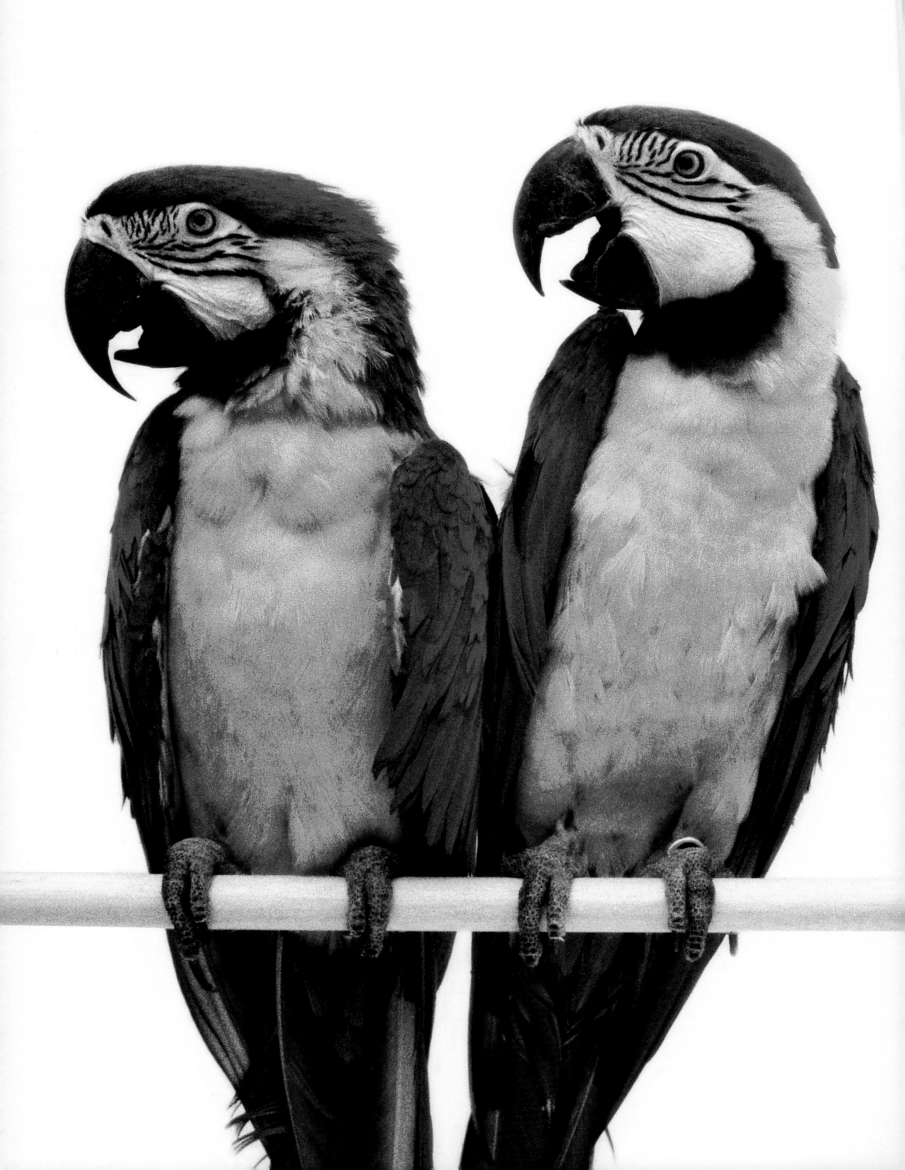

**Ararauna**  *(Ara ararauna)*  With their elephantine memory, they can really get on your nerves, particularly when they belong to the neighbors. They squeak like doors, creak like wooden steps, or growl "Drop dead!" into their whiskers at exactly the wrong moment—just like our late uncle, who brought them with him out of the African rain-forest. That's what they're like, these odd, clever birds. Scarcely have they spotted a bottle-opener in the distance than they go "pshshsht." This isn't explained by simple imitation. Their precognitive echo serves as an acoustic mirror in which we recognize our own bad habits, before carrying on with them.

**Siamese Cat**  *(Felis catus domestica)*
In the royal palaces of old Siam she
was watched over like the Pekinese in
the Forbidden City. But what has
become of the Siamese cat? Breeders
bred them so intensively that they
themselves no longer knew what
"Siamese" meant. The cats even lost
the characteristic kink in the tail. To
carry off the top prizes at the shows,
they say. It is only the discovery of
antibiotics that has made it possible to
keep a race like this alive.

Almost the only thing she shares with
the first Siamese cat which Gould, the
British Consul General, was given as
a leaving present by the Siamese king
in 1884, for breeding in Europe, are
the blue eyes. You can see the show-
champions of the time on photos
from around the turn of the twentieth
century: powerful, broad animals
with heads round as apples, which
one can well believe bring back not
just birds in their own country, but
cobras, too. With their intelligence,
and the loyalty of a dog, their original
wit and special charm, they con-
quered the western world.

Should you hear the sound of a baby
crying at night, it could well be a
Siamese cat. They miaouw over
several octaves, and at the most
unusual frequencies—perhaps out of
sadness over their lost history.

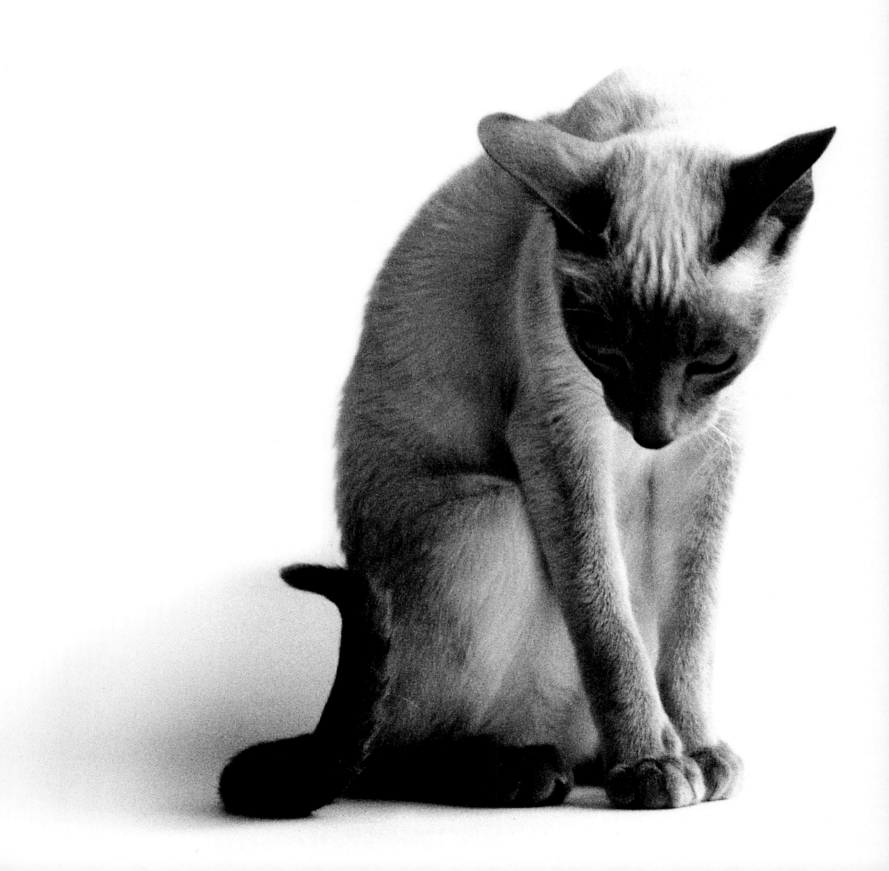

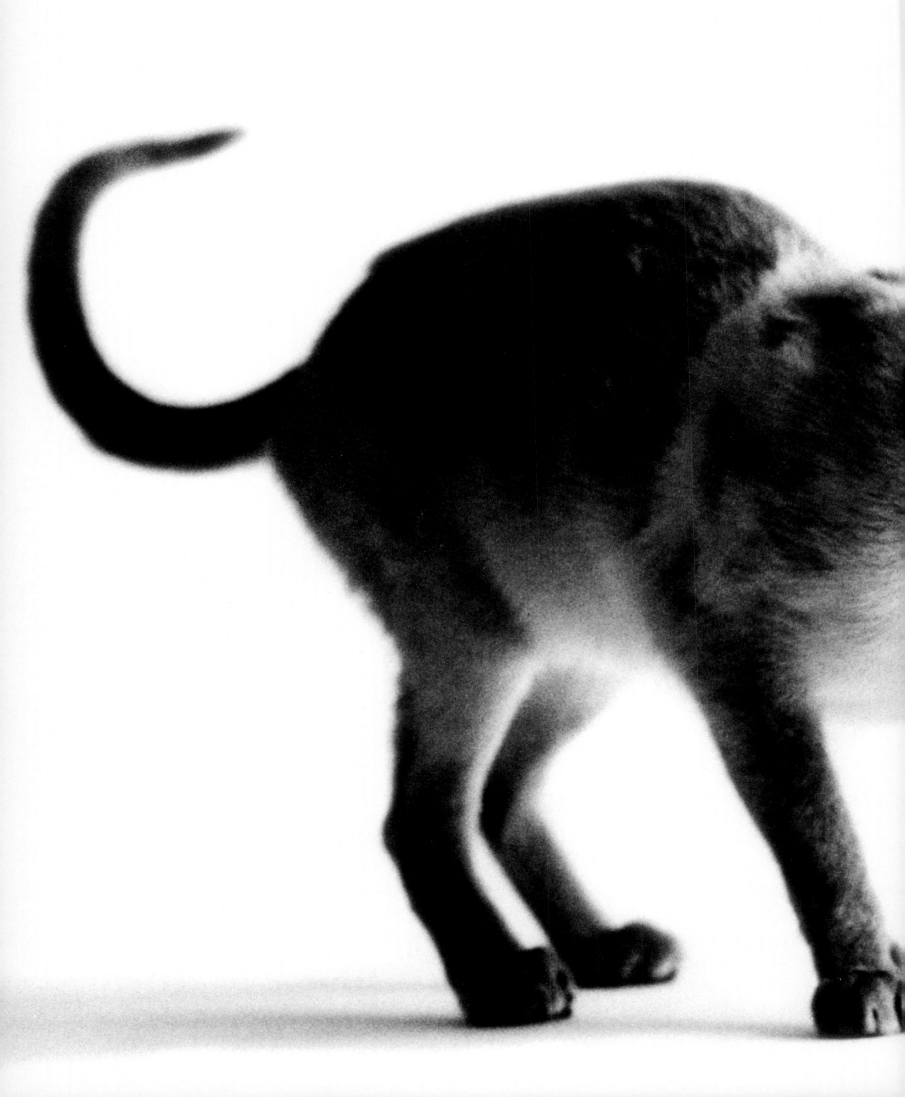

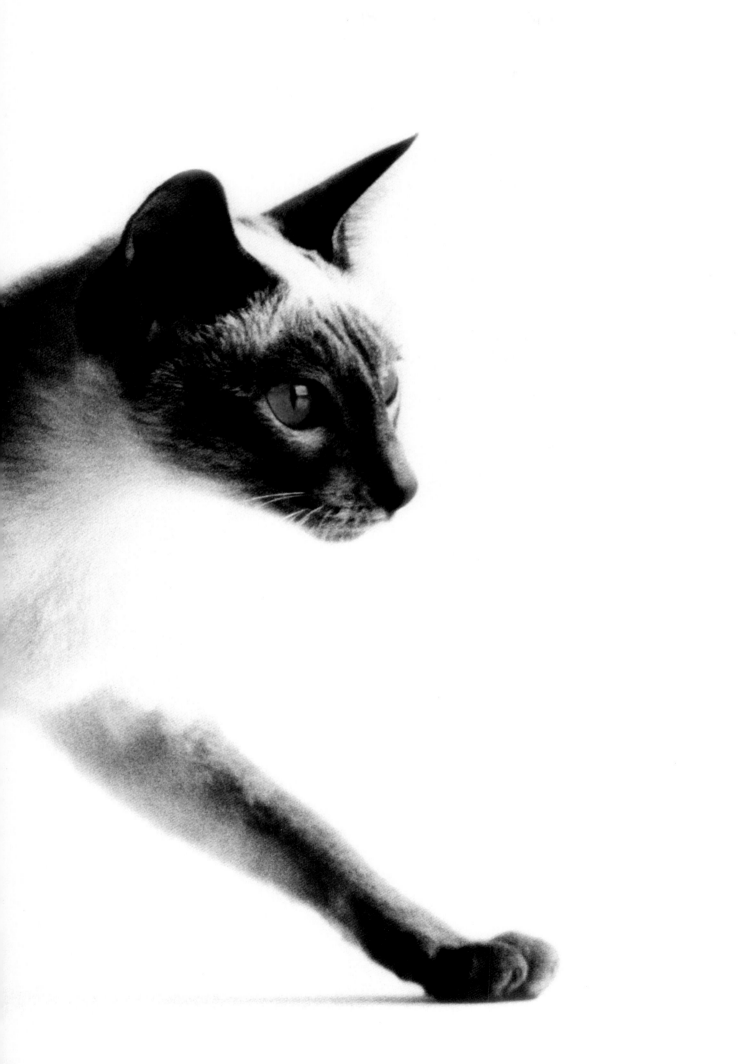

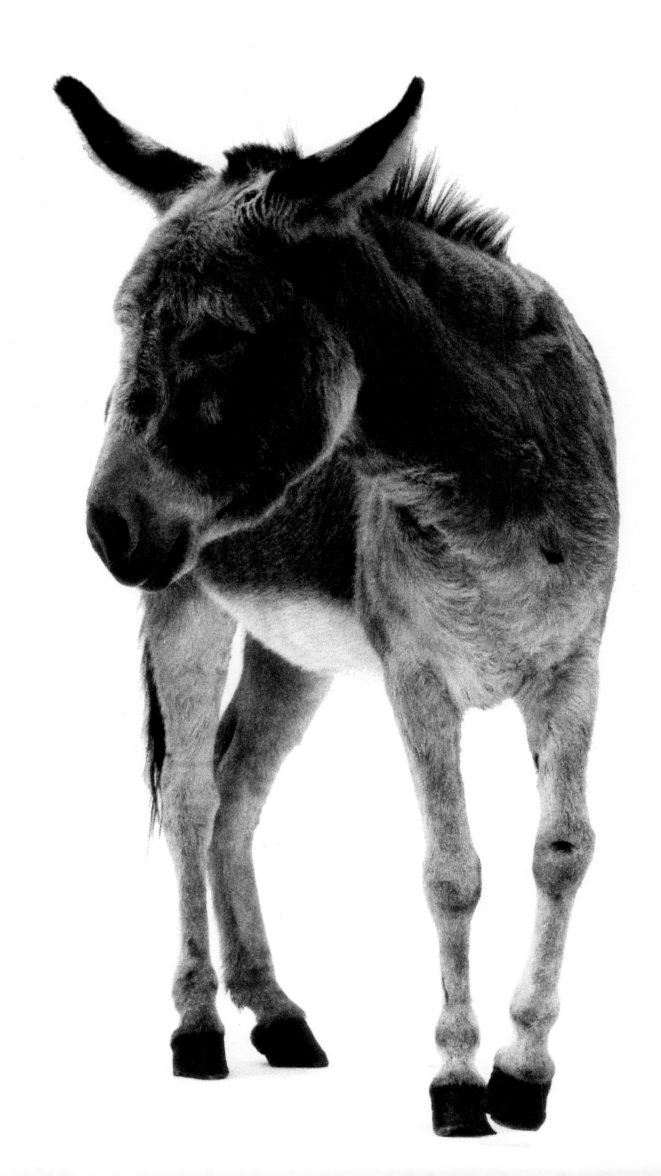

**Donkey** *(Equus asinus)* Even though he sometimes stubbornly remains standing, in the least passable parts of Africa and Asia he is still the main means of local transport. Moped and delivery-van all in one: mobile, economical and easy to maintain. A click of the tongue serves for the ignition.

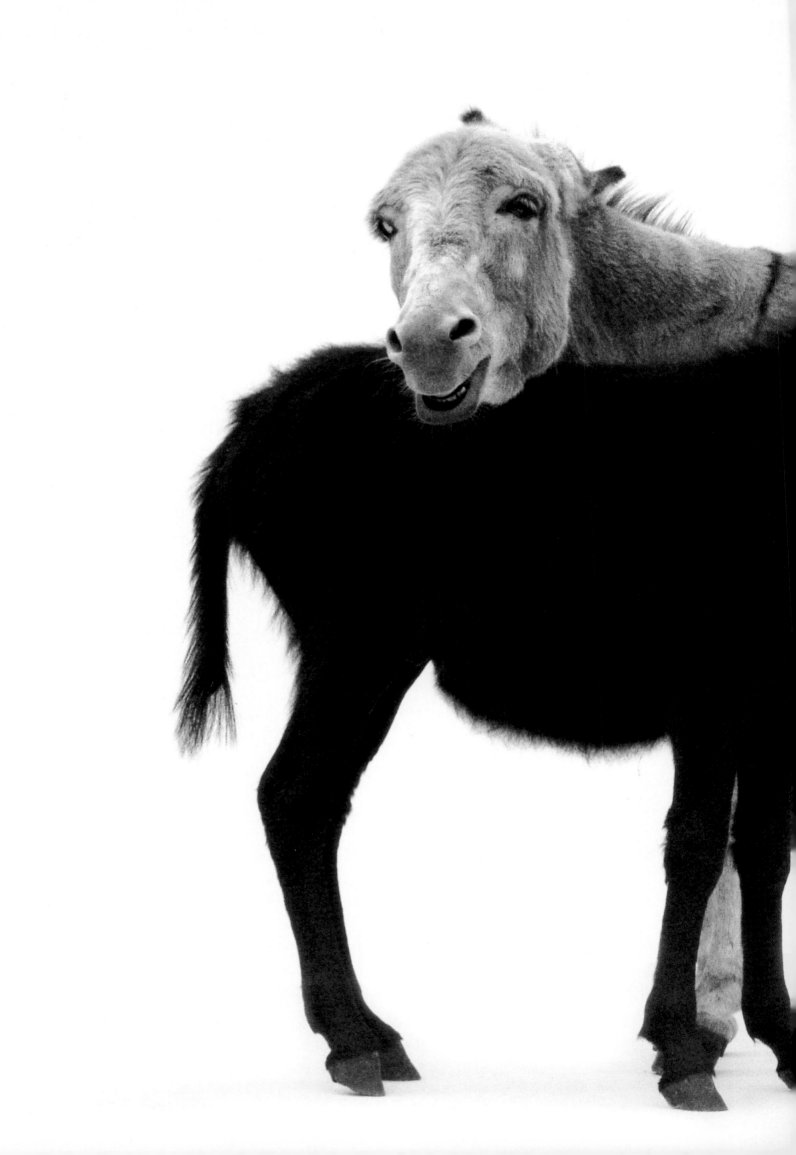

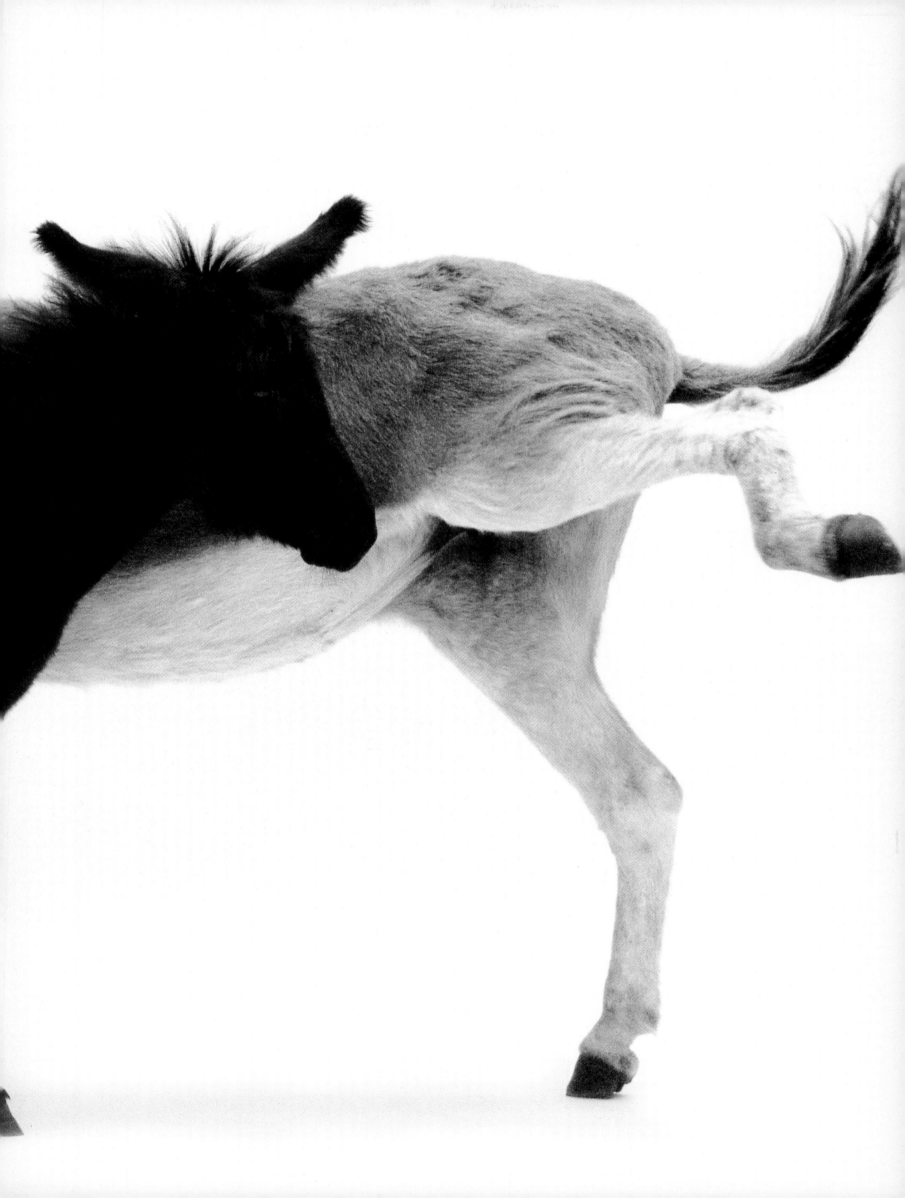

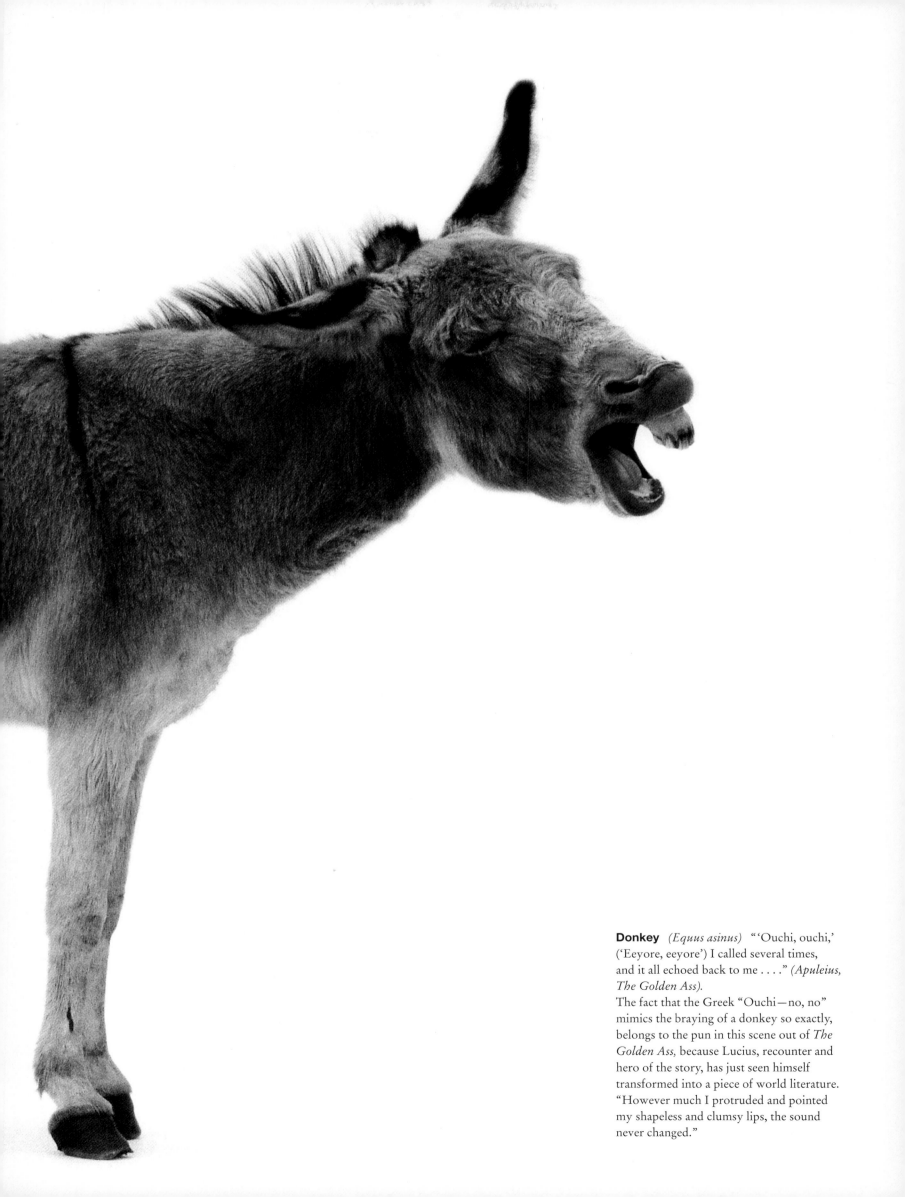

**Donkey** *(Equus asinus)* "'Ouchi, ouchi,' ('Eeyore, eeyore') I called several times, and it all echoed back to me . . . ." *(Apuleius, The Golden Ass).*
The fact that the Greek "Ouchi—no, no" mimics the braying of a donkey so exactly, belongs to the pun in this scene out of *The Golden Ass,* because Lucius, recounter and hero of the story, has just seen himself transformed into a piece of world literature. "However much I protruded and pointed my shapeless and clumsy lips, the sound never changed."

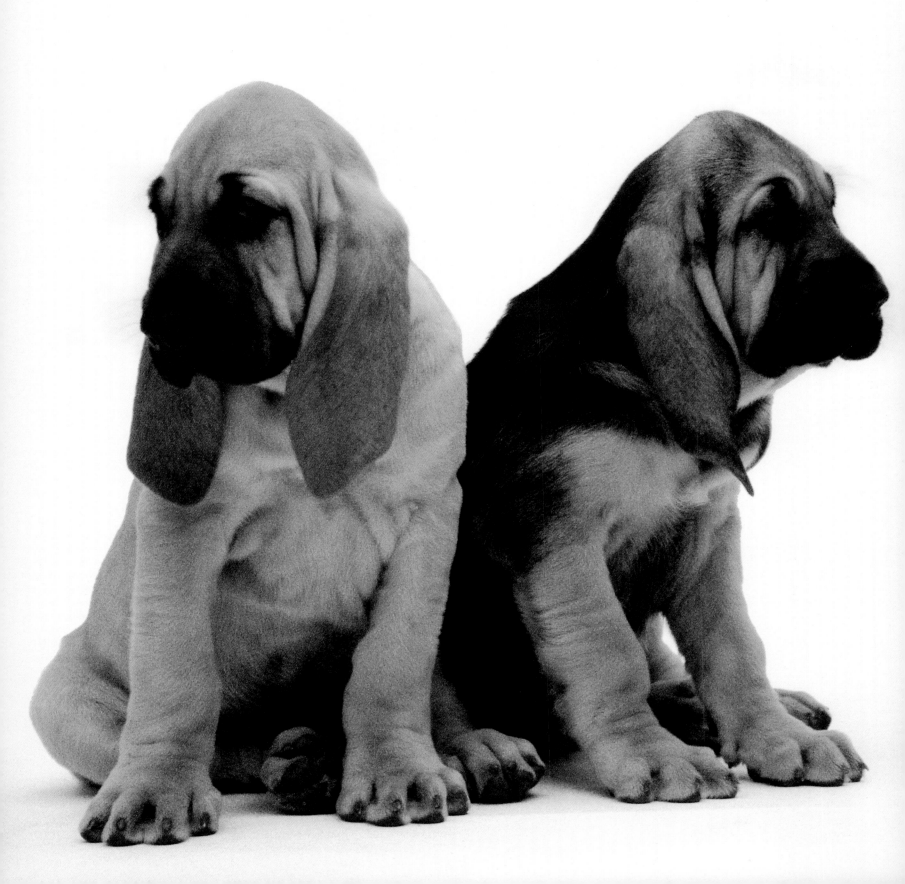

**Blood-Hound**  *(Canis familiaris)*  There they sit. Harbingers of evil, in the train of every tyrant. The idea runs like a bloody thread from left to right across the political spectrum — and through world literature. Whoever wants to oppress and exploit human beings has a blood-hound to hand. In *Uncle Tom's Cabin* as with Karl Marx. The dog with the awful reputation. But chasing and biting are not his métier. His true greatness lies in his gentleness, in his talent for following a scent. All he does is to search — and to suffer from prejudice. After all, his nose is not *his* fault. He carries on tirelessly, and can follow the merest trace of a scent over several days. Absolutely loyal, and with his nose to the ground to the end.

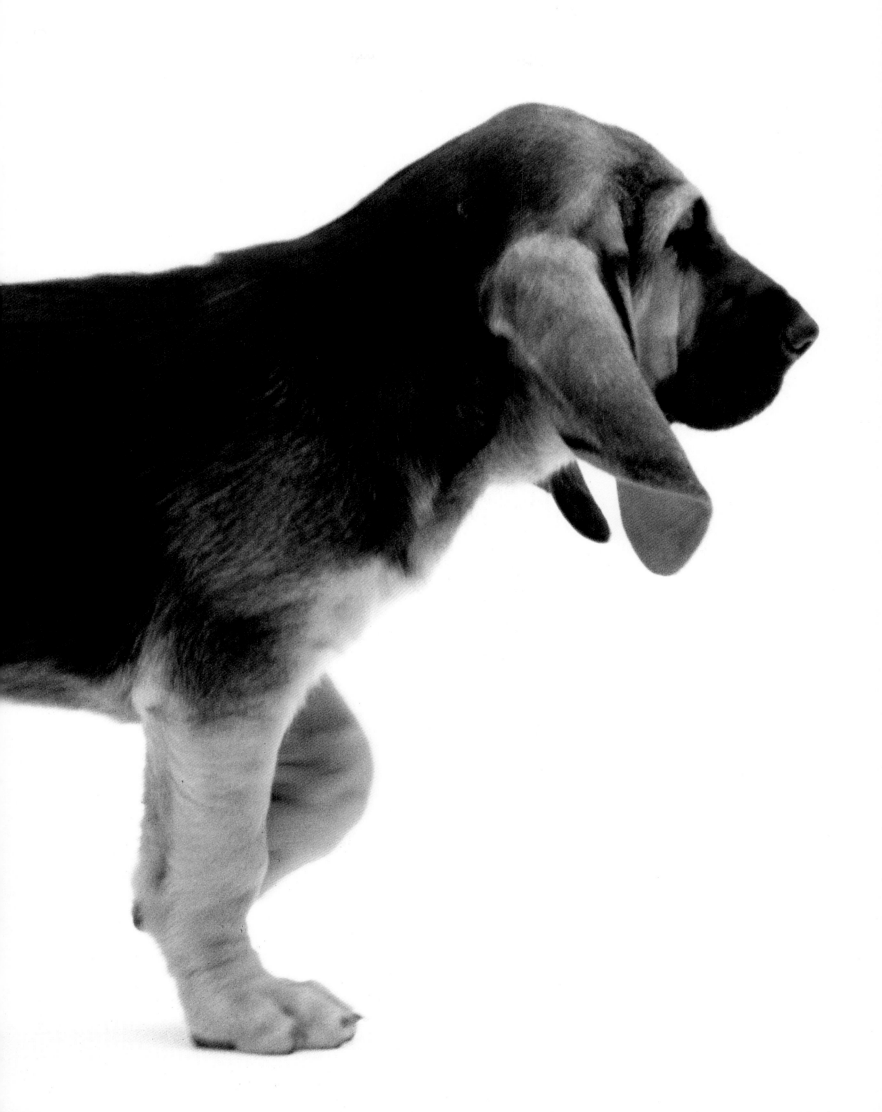

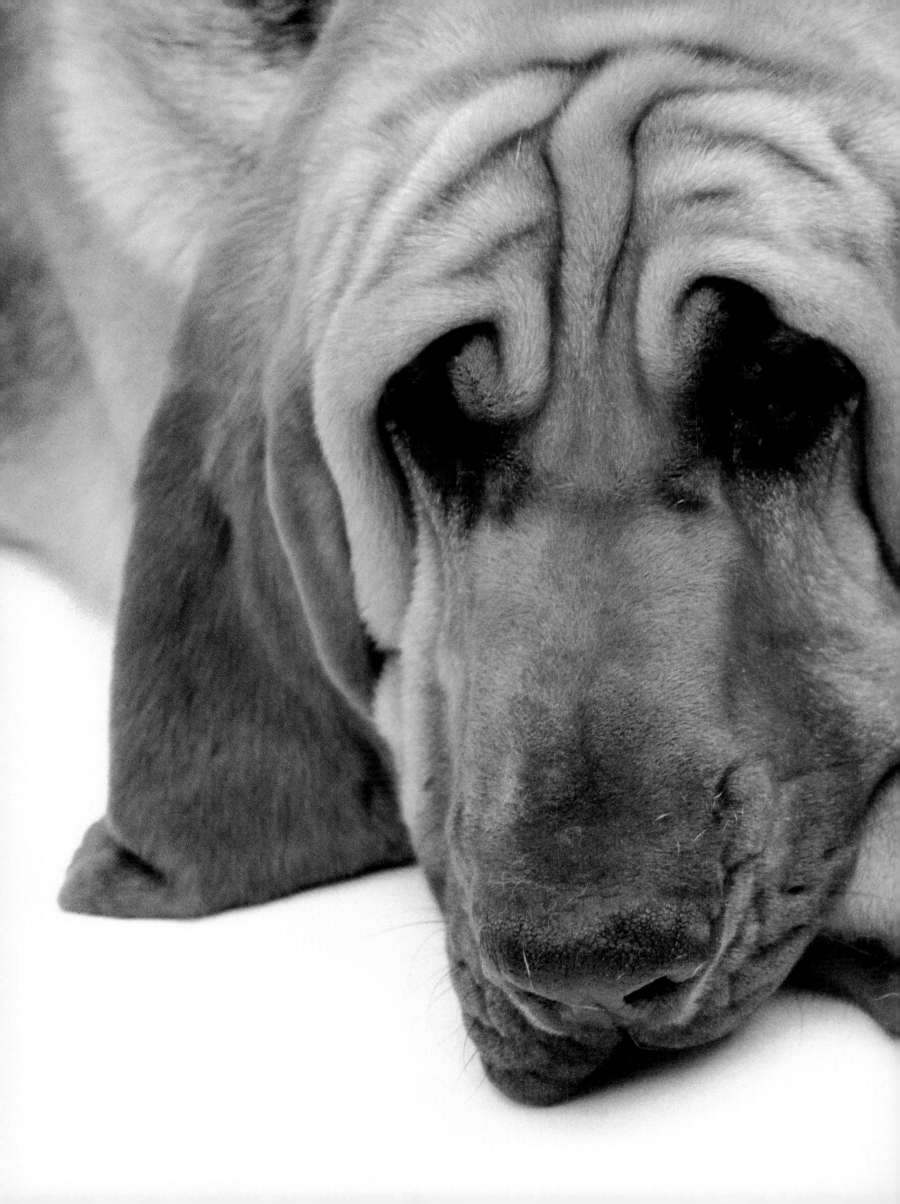

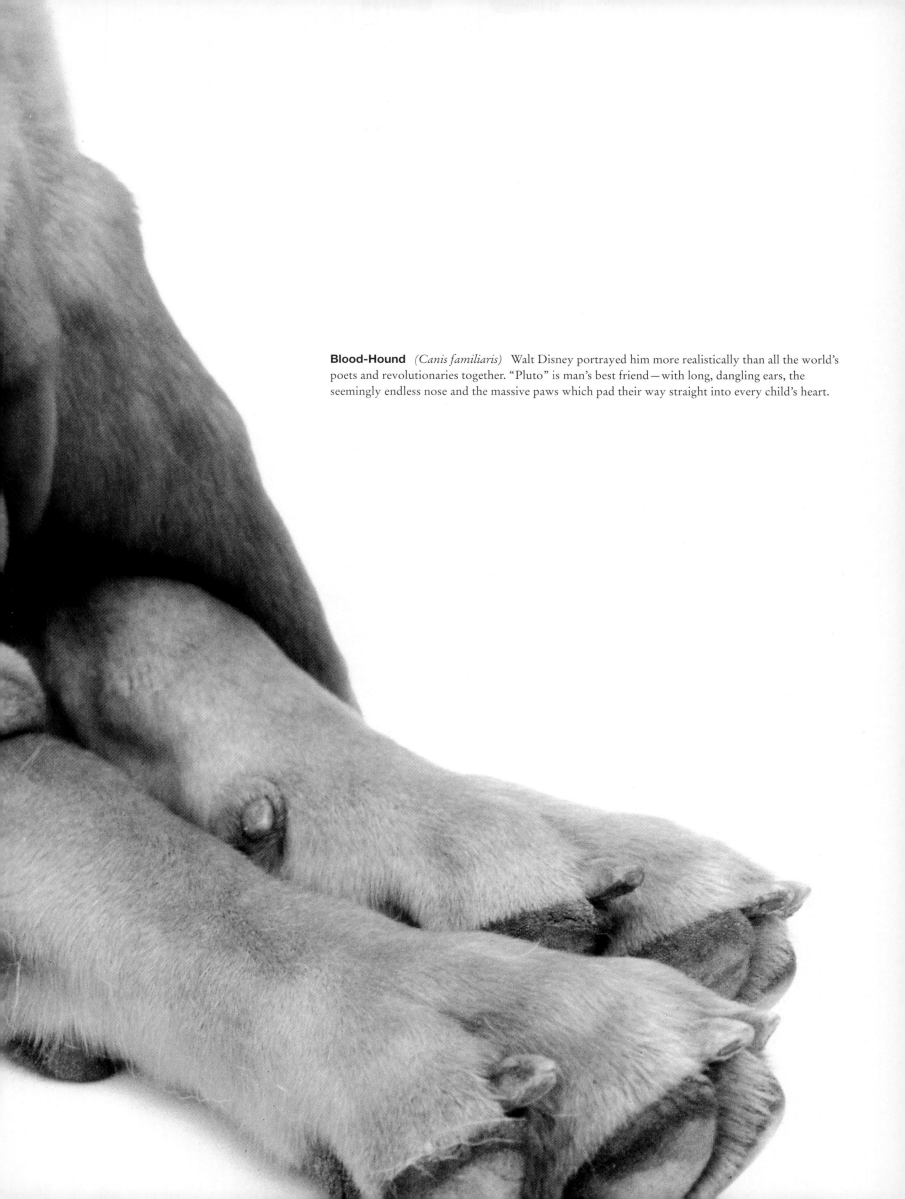

**Blood-Hound** *(Canis familiaris)* Walt Disney portrayed him more realistically than all the world's poets and revolutionaries together. "Pluto" is man's best friend—with long, dangling ears, the seemingly endless nose and the massive paws which pad their way straight into every child's heart.

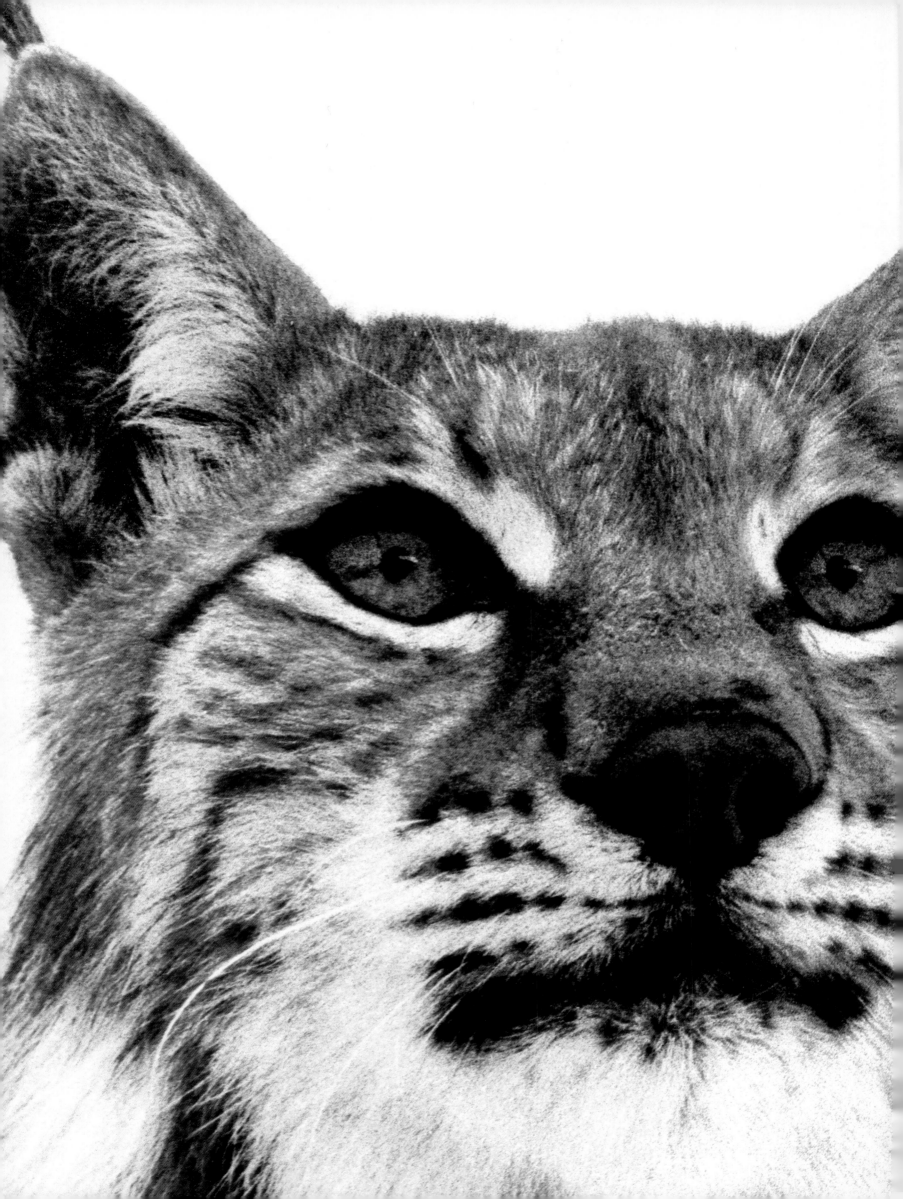

**Lynx** *(Lynx lynx)* Many a man would be proud of her eagle eyes. Whoever sees like a lynx can see in the dark six times better than an ordinary person. And to hear like a lynx: prick your ears like her.

**Lynx** *(Lynx lynx)*  Hardly any Europeans have ever seen or heard a lynx in the wild, although they have been reintroduced into the forests among us. The one great cat of Europe shares her fate with the wolf and the bear. Hunted to extinction and then reintroduced, the lynx is protected—and hated—more than almost any other animal.

"Shoot them—even one single lynx is one too many," say the hunters and shepherds, and translate their words into deeds. "Protect them," say environmentalists: "Every lynx marks out such a large territory that she remains rare anyway." Today, the lynx is probably the best-researched wild animal in Europe. That is not likely to protect her from prejudice, though. Of course, the lynx is no lamb. But does she really kill sheep from a flock indiscriminately and unrestrainedly, in surprise nocturnal attacks,—or does she not, as a shy lone animal, cull the sick and weak red deer, fox, chamois and hare? Whether or not a lynx has been responsible for a kill, you can easily see from her table manners. She returns to the kill time and time again, and gnaws it down to the bone until only skin and sinews are left, as if a biologist had prepared an anatomy lesson.

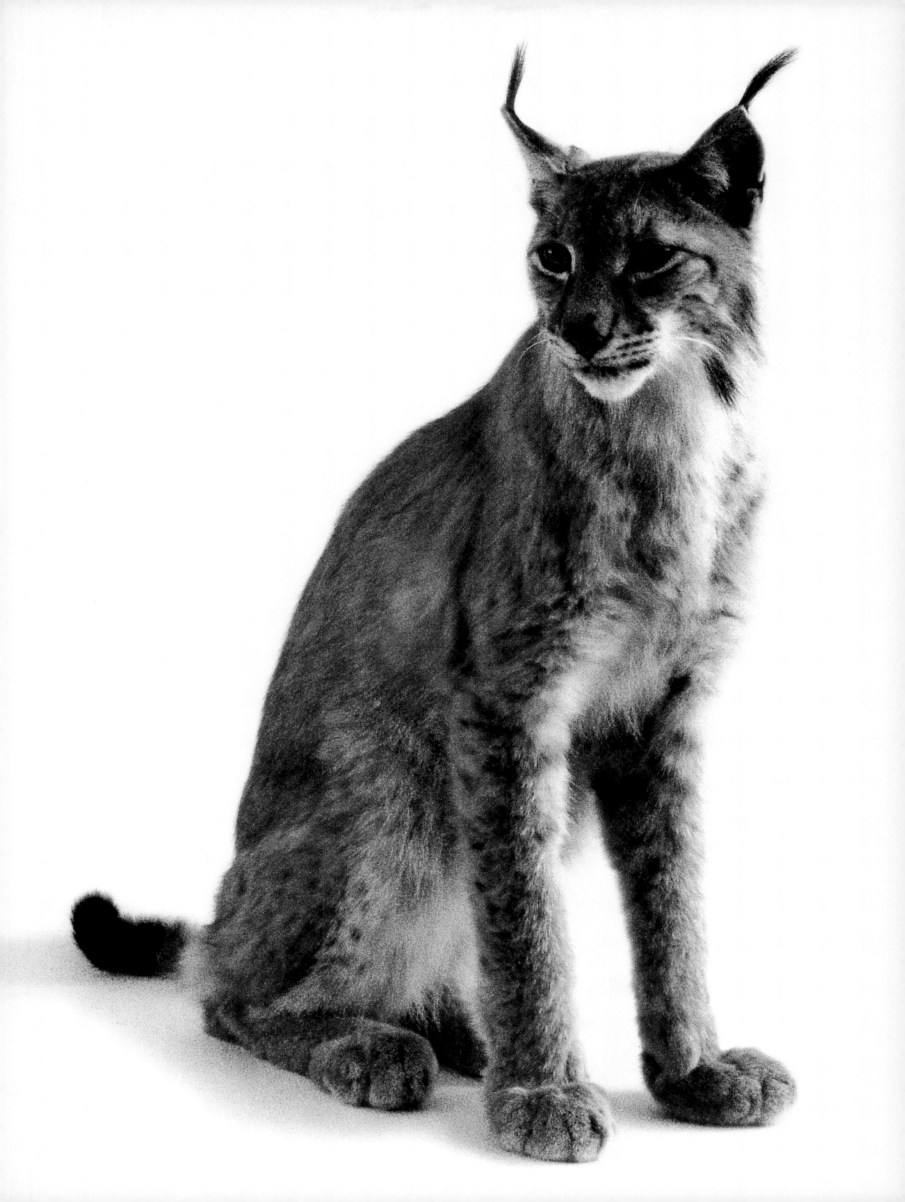

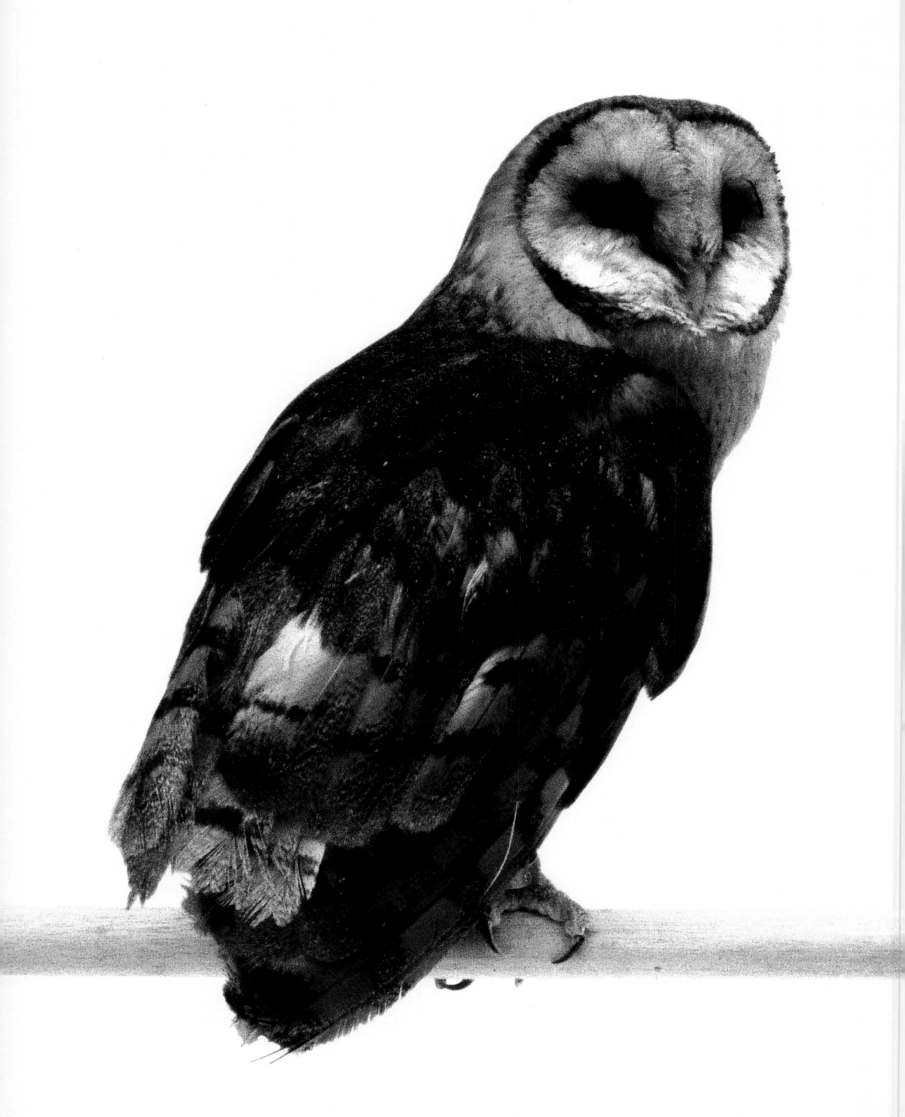

**Barn Owl** *(Tyto alba)* Just a minute, please. Look her straight in the eyes. She will not be able to look away. Owls have a fixed stare and to look away they have to turn their neck. She can do that three quarters of the way round, and so far upwards that her head seems to be upside down. She funnily turns her head backwards and forwards so often, so as to better gauge her distance from the creature in front of her, with her far-apart eyes. Since she can hardly see better at night than a human being, she severely restricts her hunting-ground to the area round her nest. Her highly sensitive pupils meanwhile—even in daylight—should help her to recognize: I am an owl on white.

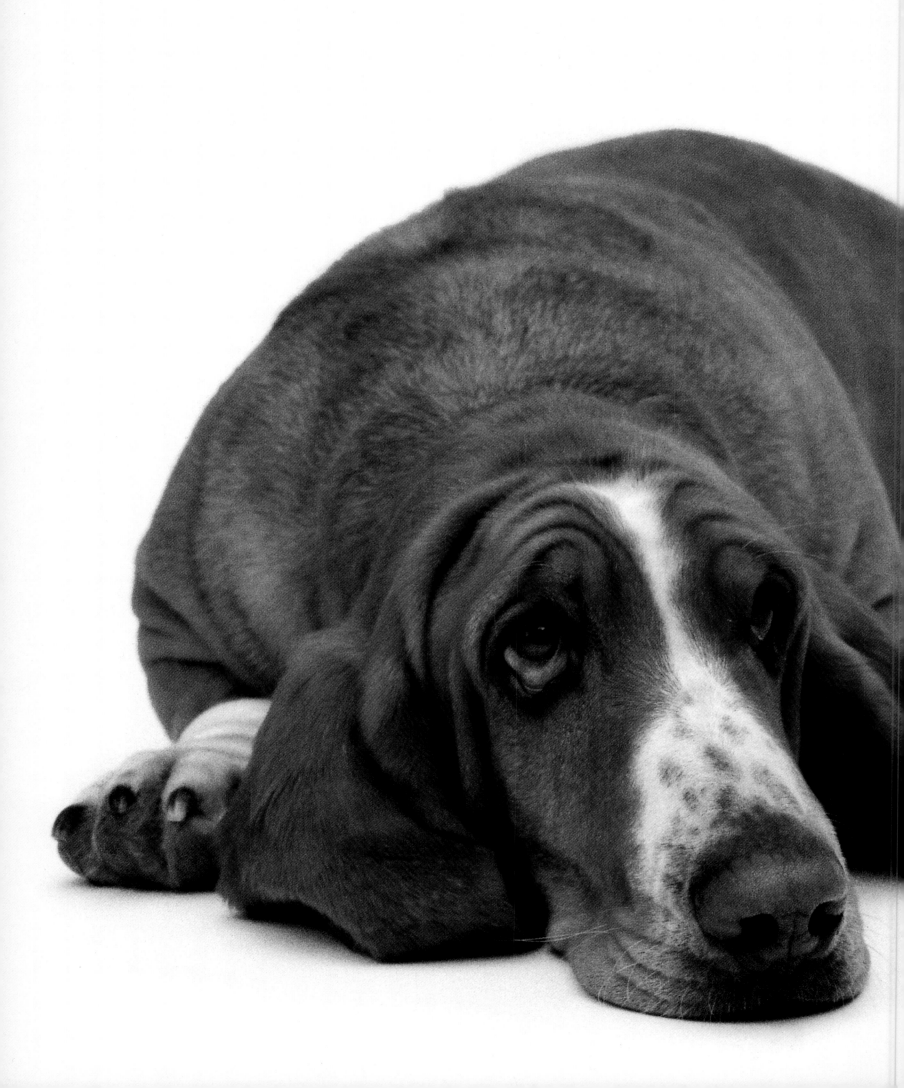

**Basset Hound** *(Canis familiaris)* Sir John Everett Millais—as one of the founders of the English Pre-Raphaelite school of painters—has an important place in the history of English art, but his most popular work is the basset hound. By crossing an English bloodhound with dwarf mutants of the French greyhound he ensured a future for the older race. The basset hound hardly speaks for the aesthetic sensibilities of the painter but, as we all know, art demands other qualities besides beauty. What other hound apart from him found his way into *A Midsummer Night's Dream?*

"With ears that sweep away the morning dew,
Crook-kneed, and dewlapped like Thessalian bulls. . . ."

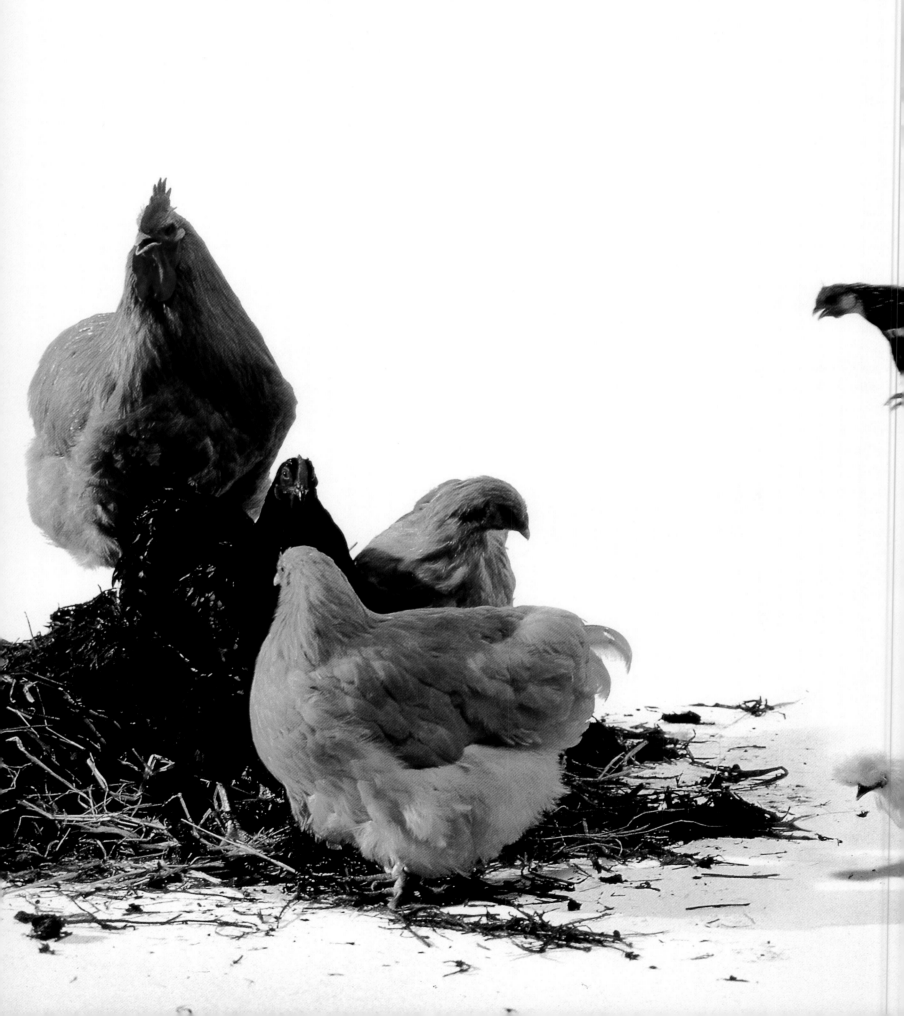

Orpington cock and Orpington hens, Wyandotte hens (in-between), small Silkie and Hamburg bantam. In the cage, two out of the six thousand million population of nameless battery-hens.

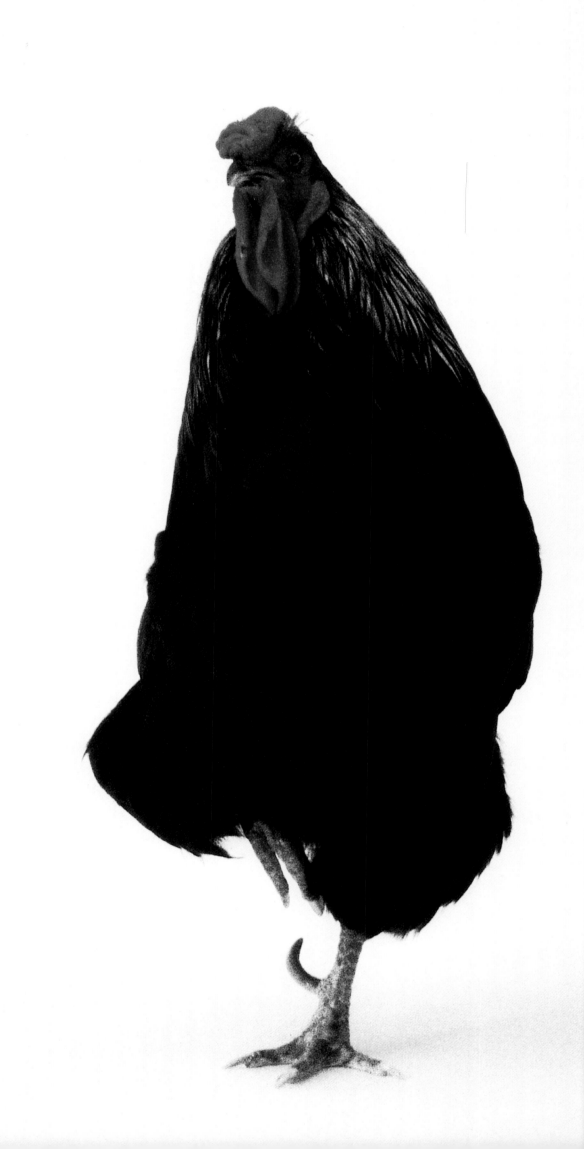

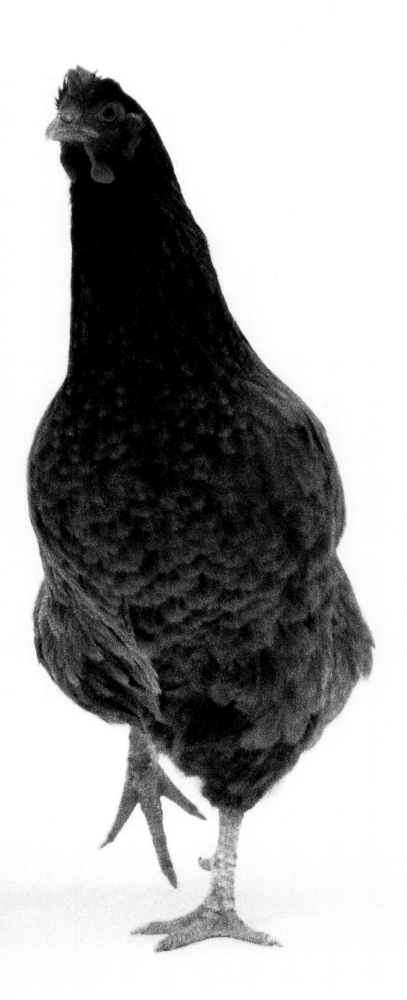

**Cock and Hen** *(Gallus gallus f. domestica)*
The question of which came first—the chicken or the egg—is more of a philosopher's question. Developmental history speaks for the egg. How would you like it done? Three, four or five minutes?
Until the egg hatches into a chicken, the hen needs to brood for twenty-one days. Of course, the incubator does this, too—but not a second quicker. A hen's life is not all fun and frolic. One kind lays an egg a day for fifteen months, the other lands on a plate after thirty days. But still: lucky hens! With few exceptions, the young cocks are ground into bone-meal the day they hatch out. With approximately six thousand million hens, the earth is about equally populated with hens and human beings.

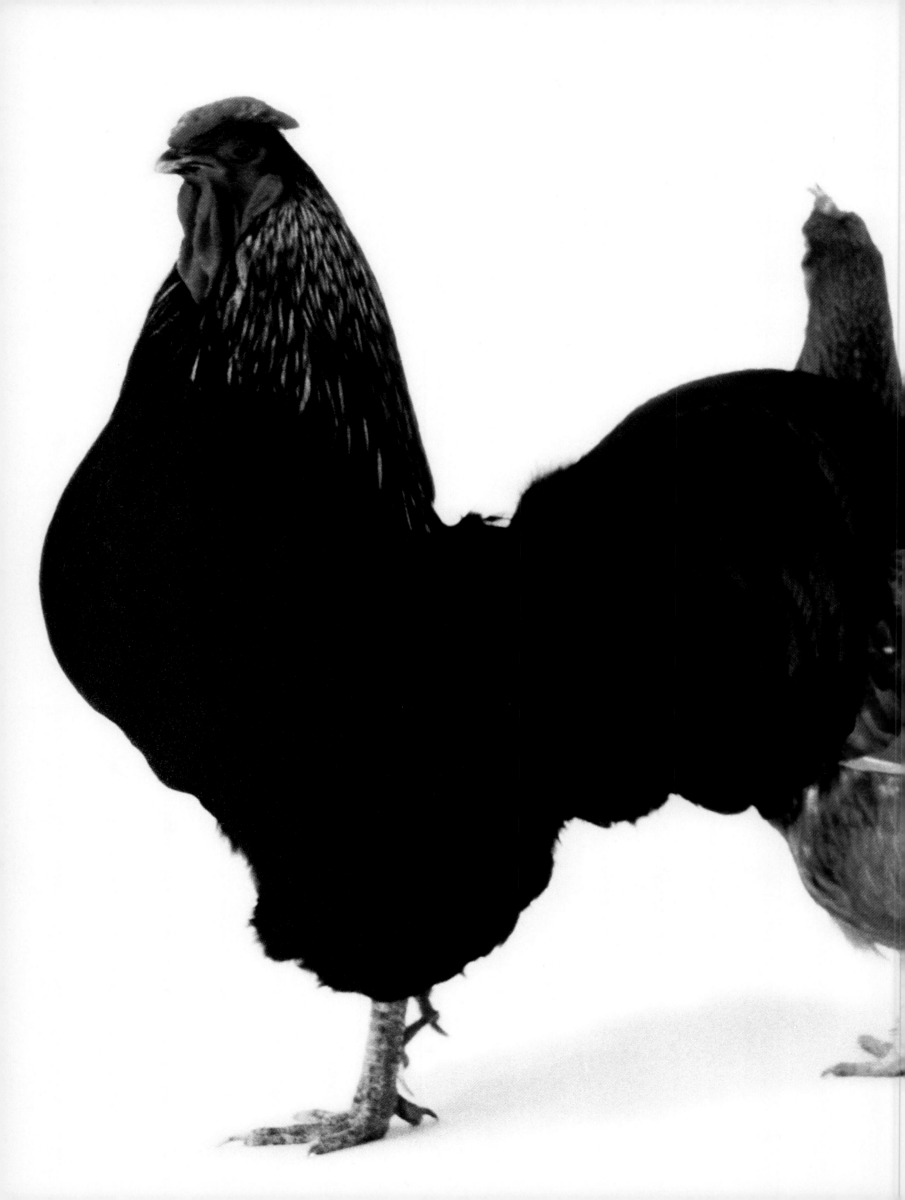

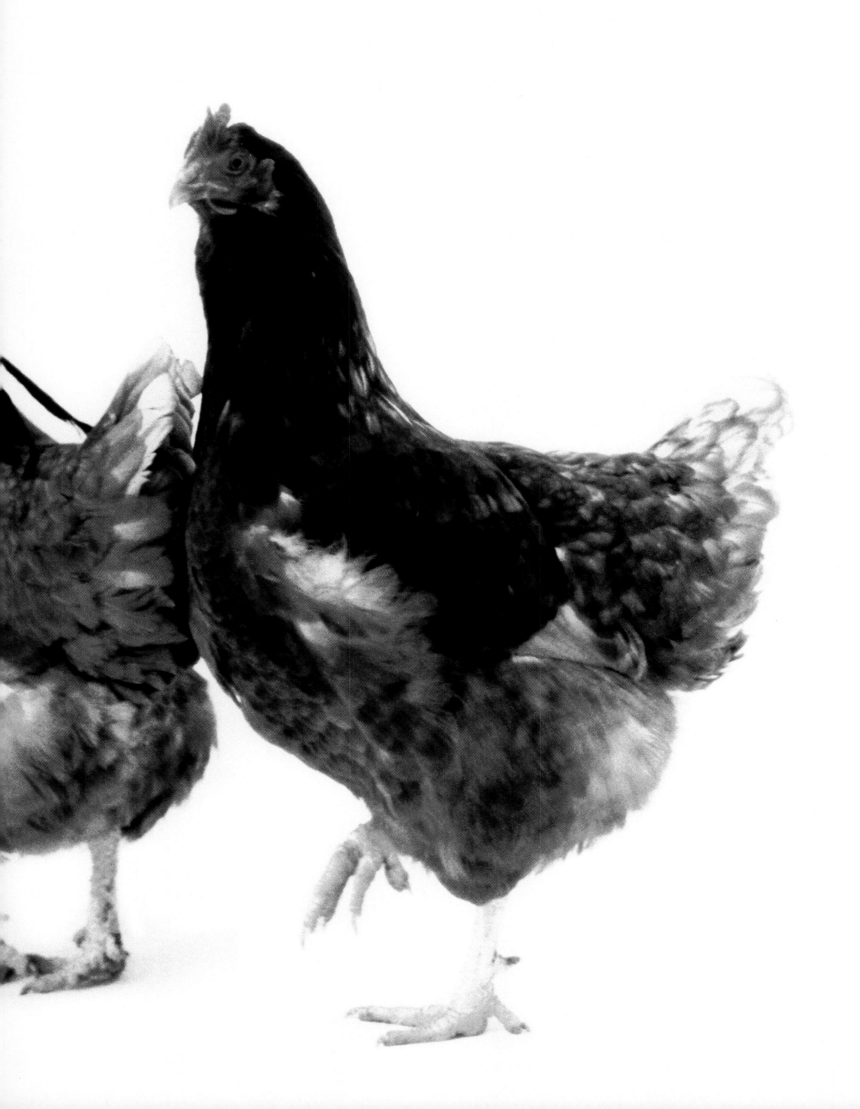

**Maine Coon** *(Felis catus domestica)*

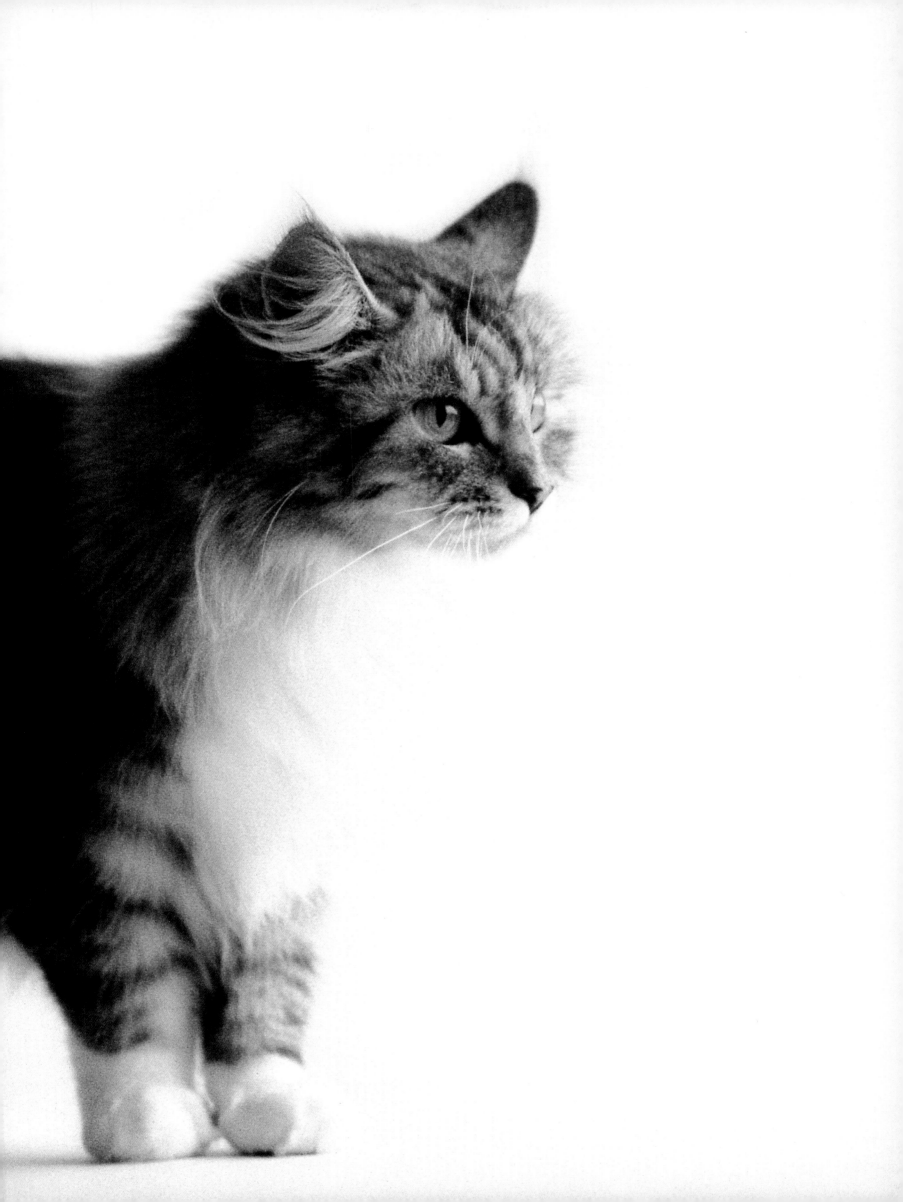

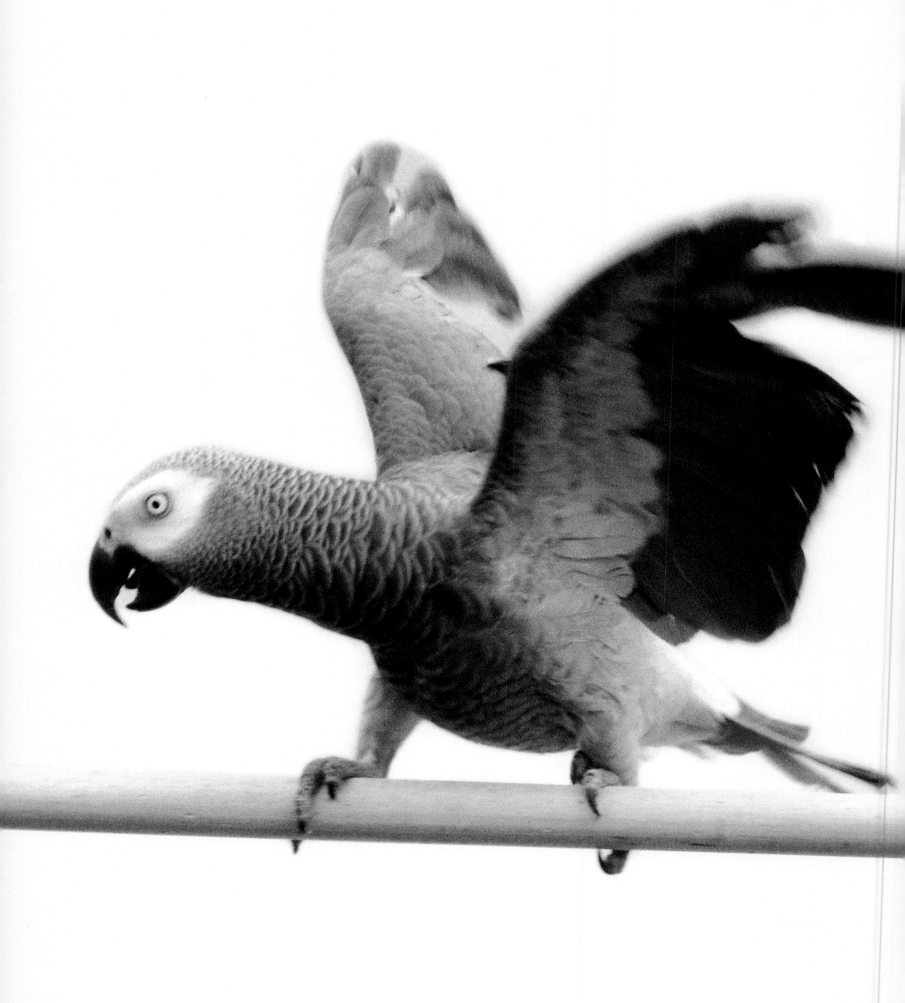

**Grey Parrot**  *(Psittacus eritacus)*  What is the point of all the talk? A substitute for action—it's all a life-long attempt to find happiness. A parrot is really only talkative when it is lonely—though not so lonely as to tweak at its feathers just to see if it is still alive at least, if not exactly happy. A parrot is never really happy. Except with another parrot, as a couple. But then that happiness lasts a lifetime, however long that may be. True happiness can only be attained in paradise, the realm of the parrot's origins, of which its colors are a clear reminder. In civilized surroundings, parrots have scarcely ever opted to reproduce. They dream of a better world.

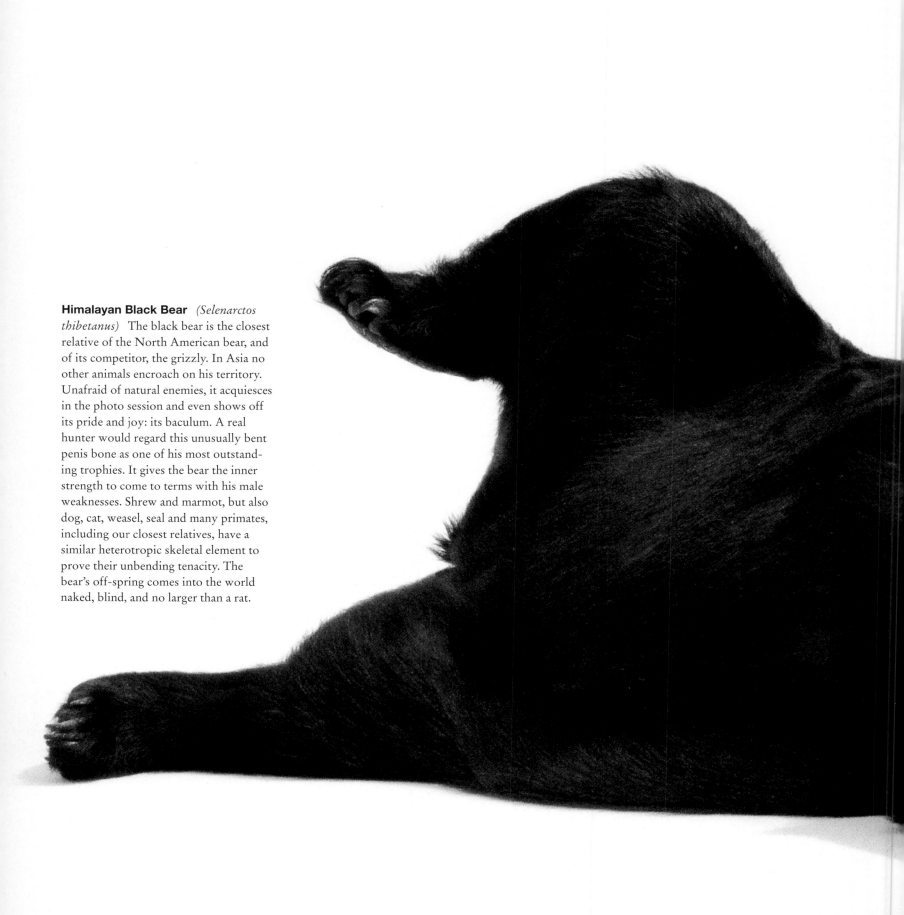

**Himalayan Black Bear** *(Selenarctos thibetanus)* The black bear is the closest relative of the North American bear, and of its competitor, the grizzly. In Asia no other animals encroach on his territory. Unafraid of natural enemies, it acquiesces in the photo session and even shows off its pride and joy: its baculum. A real hunter would regard this unusually bent penis bone as one of his most outstanding trophies. It gives the bear the inner strength to come to terms with his male weaknesses. Shrew and marmot, but also dog, cat, weasel, seal and many primates, including our closest relatives, have a similar heterotropic skeletal element to prove their unbending tenacity. The bear's off-spring comes into the world naked, blind, and no larger than a rat.

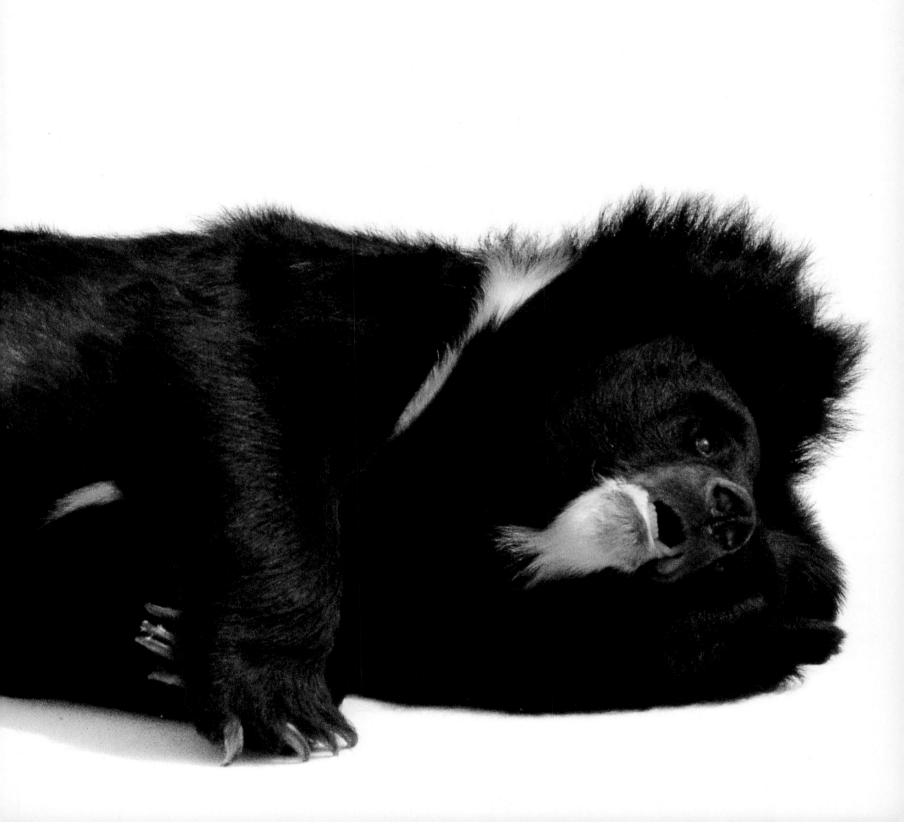

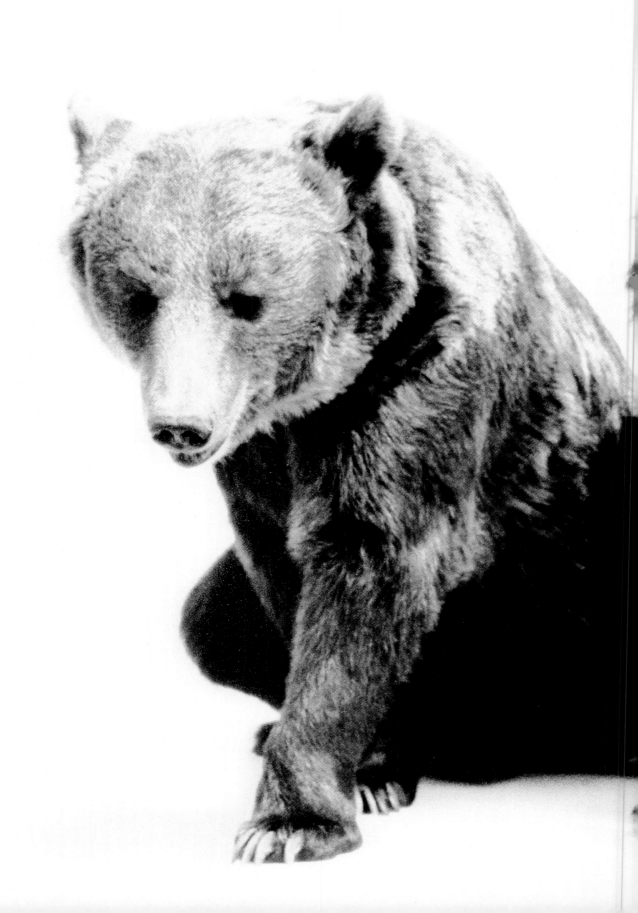

**Brown Bear** *(Ursus arctos)* **and Himalayan Black Bear** *(Selenarctos thibetanus)*

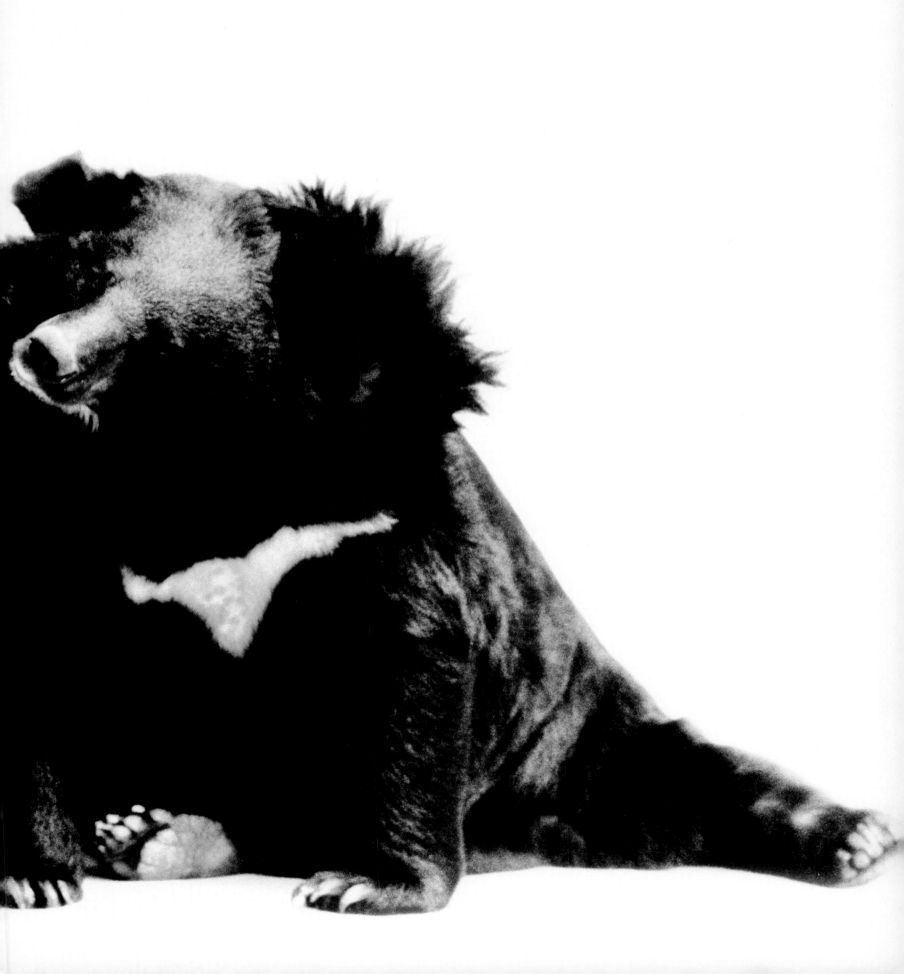

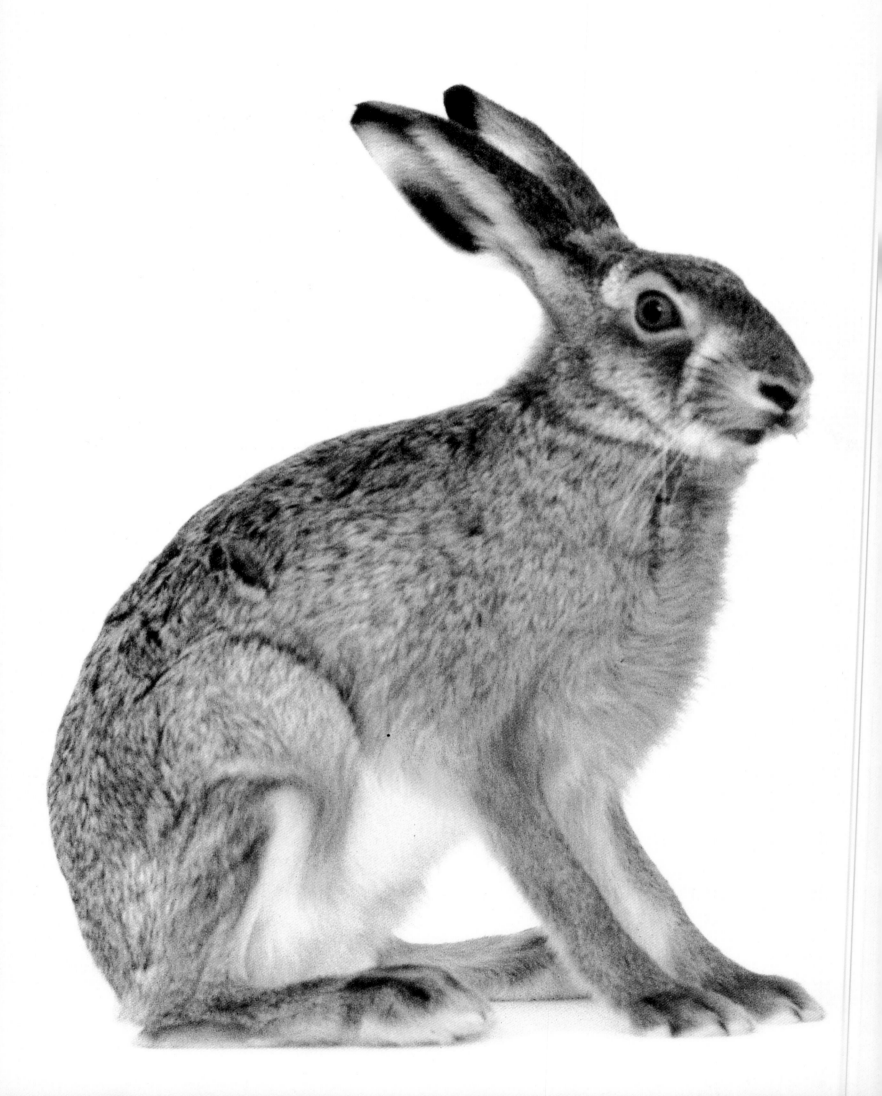

**European Hare** *(Lepus europaeus)* Hare or rabbit? Who knows the seven differences between them? One can skin both of them, but only domestic rabbit-skin is used to make coats and boots.

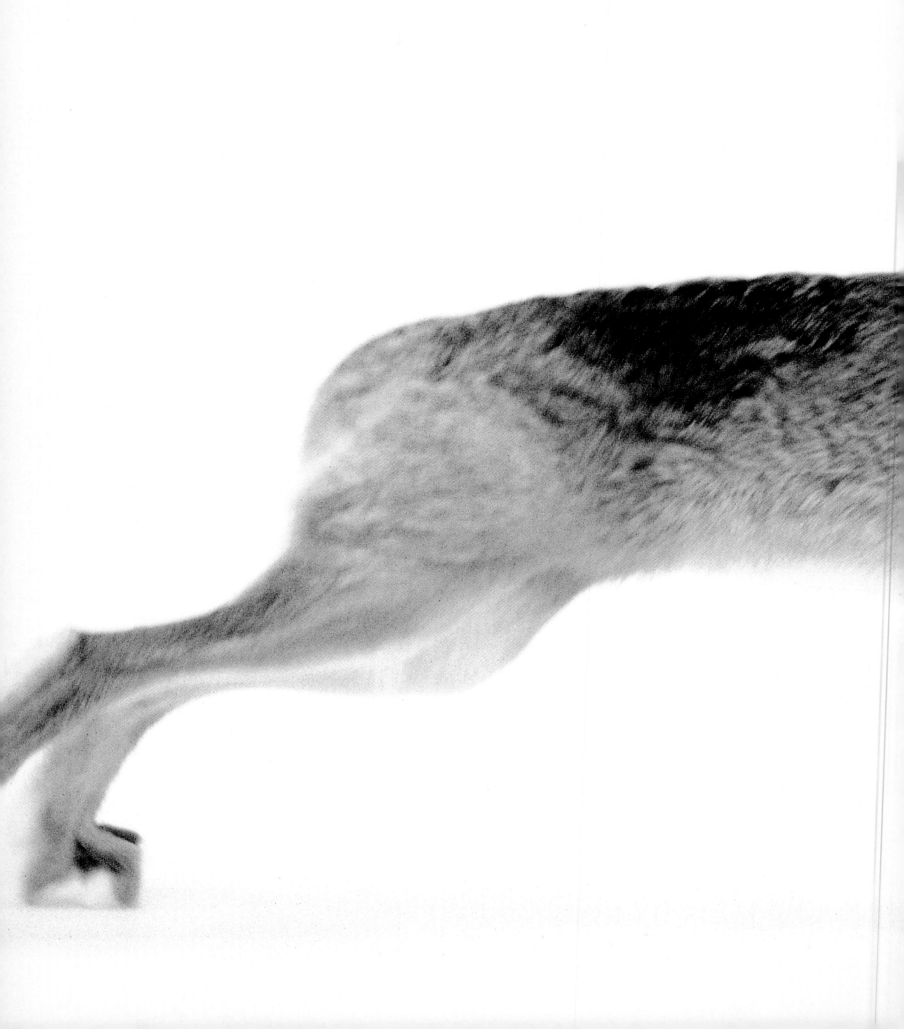

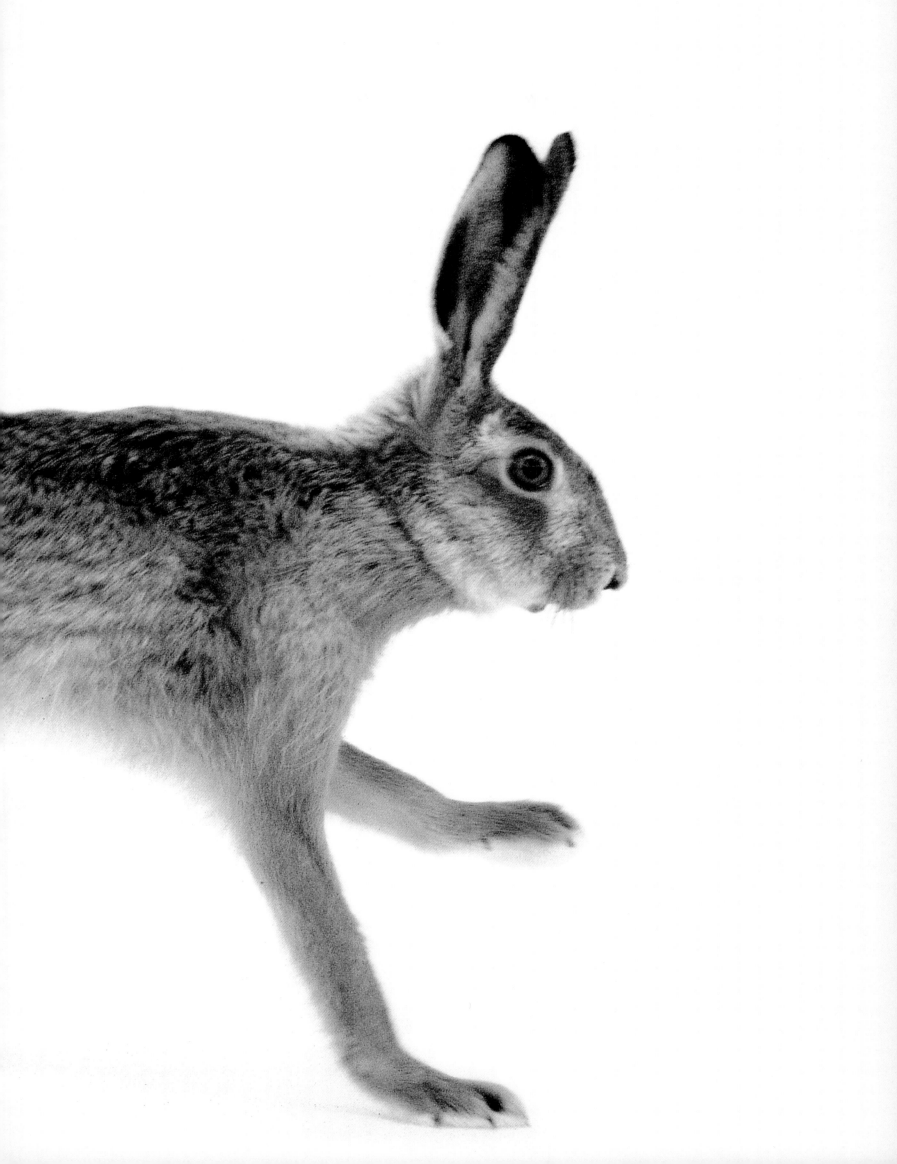

**European Hare** *(Lepus europaeus)* Better at flight than at fighting, but so much the more excitable in love, and as prolific as the Garden of Eden, to some men he is a secret ideal. In Byzantine symbolism the hare represents Jesus. Like the lamb—the helpless victim. That's how it is with anthropomorphized animals: they display contradictory traits, just like us.

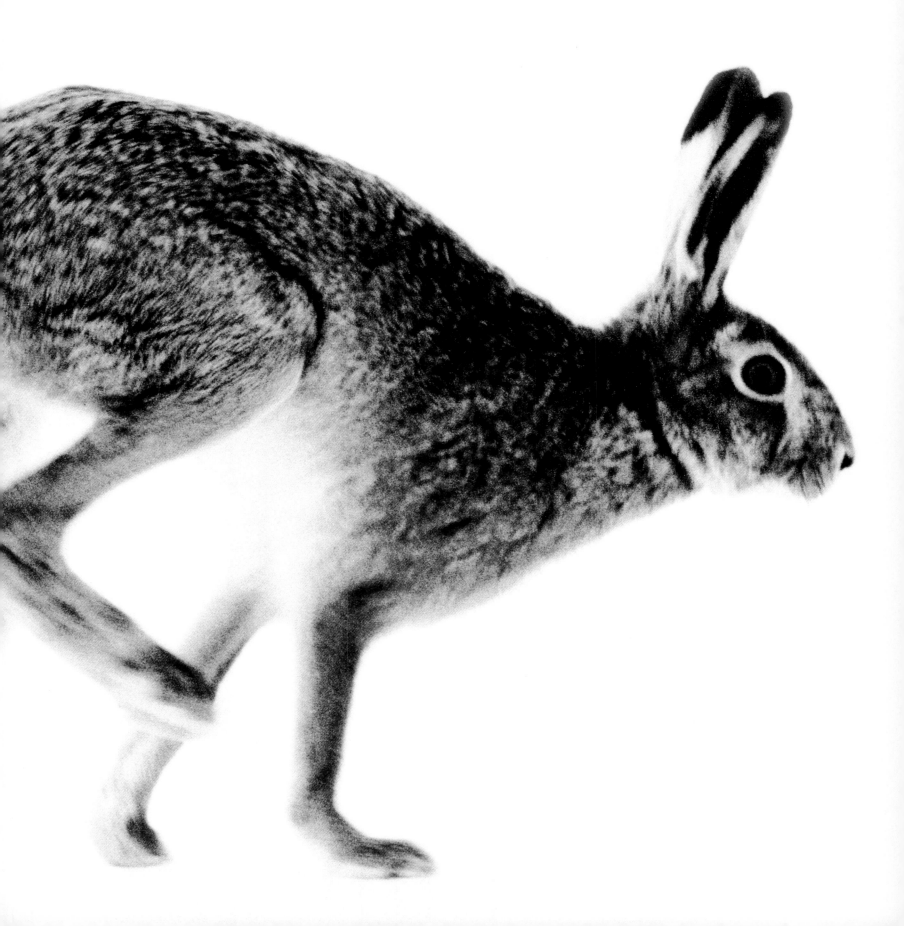

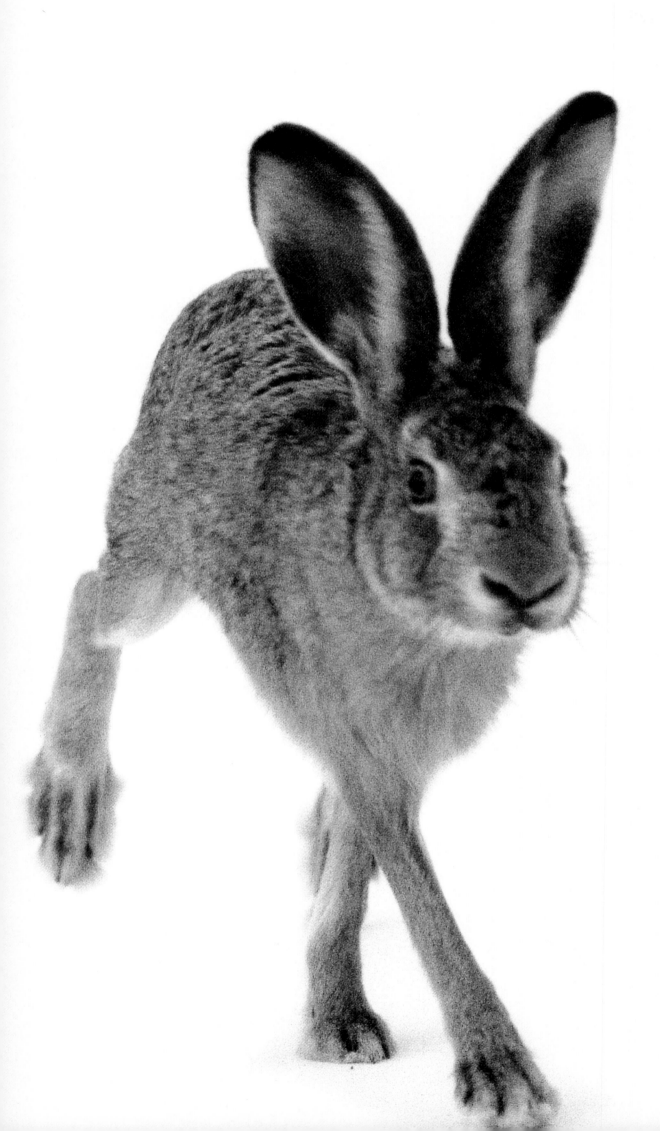

**European Hare** *(Lepus europaeus)*  Albrecht Dürer drew him on white in almost exactly the same way. Just before the leap. The first rays of the winter sun stir him into activity—and then the bucks fight for the favors of the doe. This sentence alone contains two hunting terms. The hunted, since time immemorial. He runs across the night sky at the feet of the hunter Orion, pursued by a dog. He is easy to recognize. In his catalogue, Ptolemy labels the stars: i, k, n and l are the ears, m the chin, e the front paws, and a and b the body. We will let him run for a while.

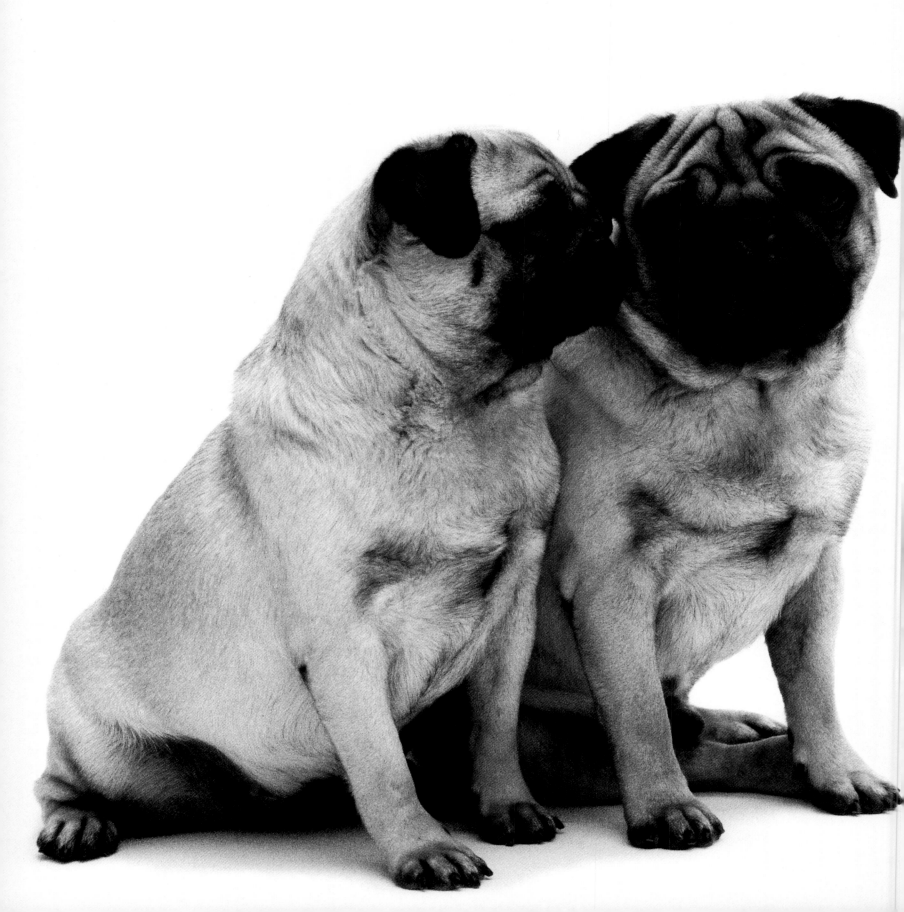

**Pug** *(Canis familiaris)* If it is true that tragedies repeat themselves as comedies, then in the pug we have a walking farce. His ancestor was after all the legendary Molossian hound, who as a four-legged gladiator performed acts of doubtful valor in ancient Rome. And so he became the black sheep among the dogs: what a come-down for the clan of bull-baiters, to discover a yapping cushion in their ranks!

Fatties always have a hard time of it. When one is born into the world with such a snub nose that one appears short of breath, sensitive to the heat and almost crippled due to loose knee-caps, one can be sure of being made fun of. Of course excesses are to be avoided, say serious breeders, but even they laugh from time to time. The way the pug, shunned by the world, crumples up his face, then cheekily pants for attention with his wet tongue hanging out, only to flop contentedly into his basket,—that has a panache which any dandy would give his eye-teeth for.

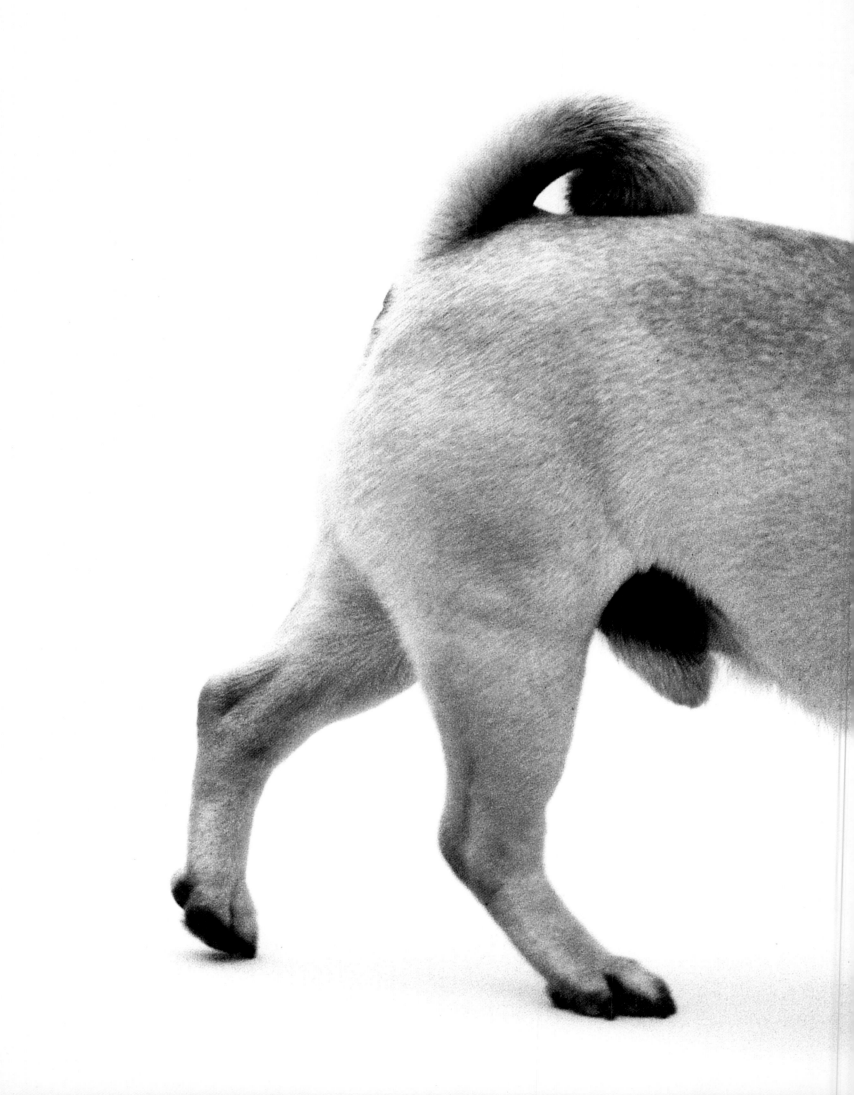

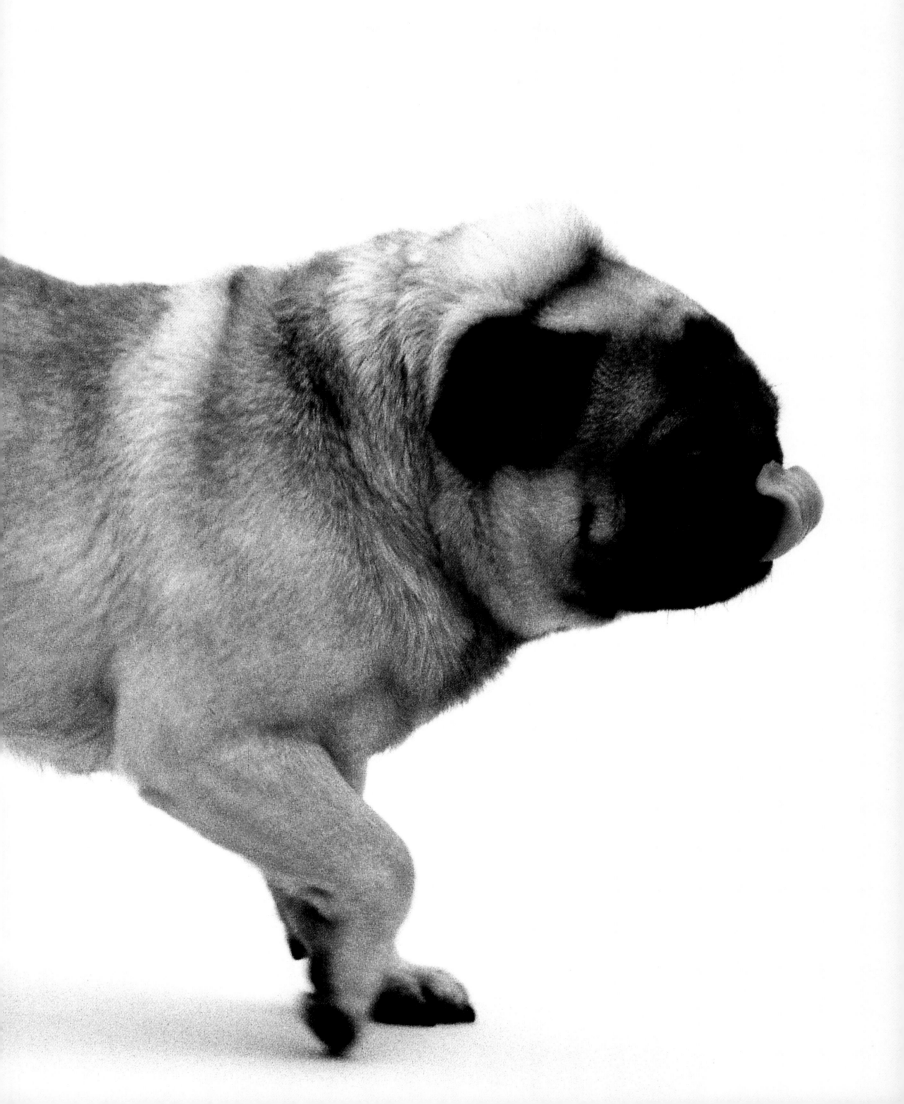

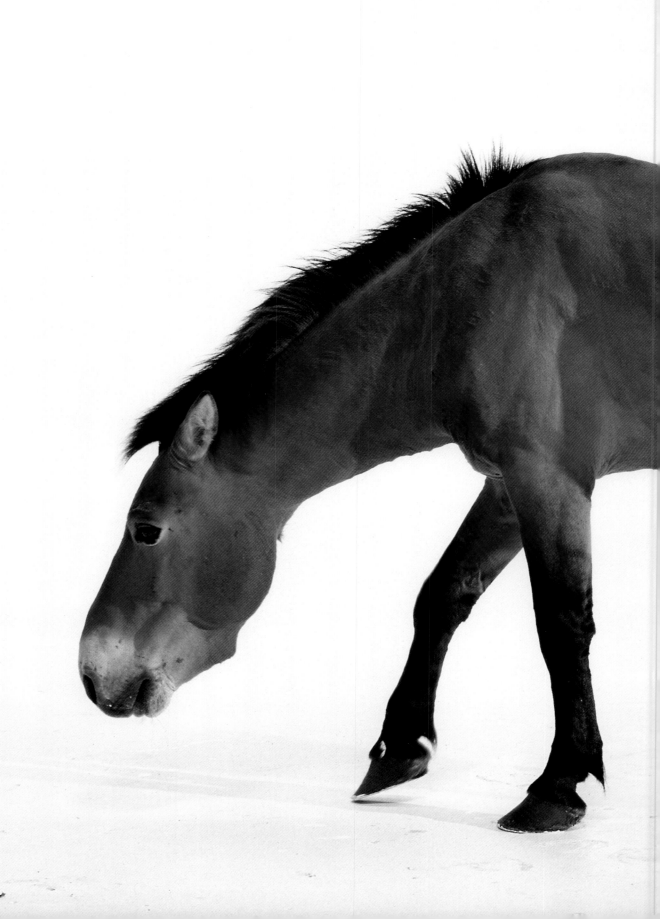

**Przewalski Horse, or Tachi** *(Equus przewalskii)*  One horse-power. "A horse! A horse! My kingdom for a horse!" cries Shakespeare's Richard III during the Battle of Bosworth. Only a horse could have saved his life. Genghis Khan established an empire on horseback. In the year 1879, at the heart of the famous Mongol empire the Russian general and explorer Nikolai M. Przewalski came upon the only surviving specimen of the three original species of horse—and his name thus went down in history. A prey for early hunters, the Przewalski horse crossed the Asian steppes in small herds. Its traces are to be found in Europe in the Altamira cave drawings.

Today's specimens stem from thirteen zoo animals. Several years ago, a few dozen were returned to the freedom of the Mongolian national park Hustain Huruu. His Royal Highness Prince Bernhard of the Netherlands is looking for support for "this unique project."

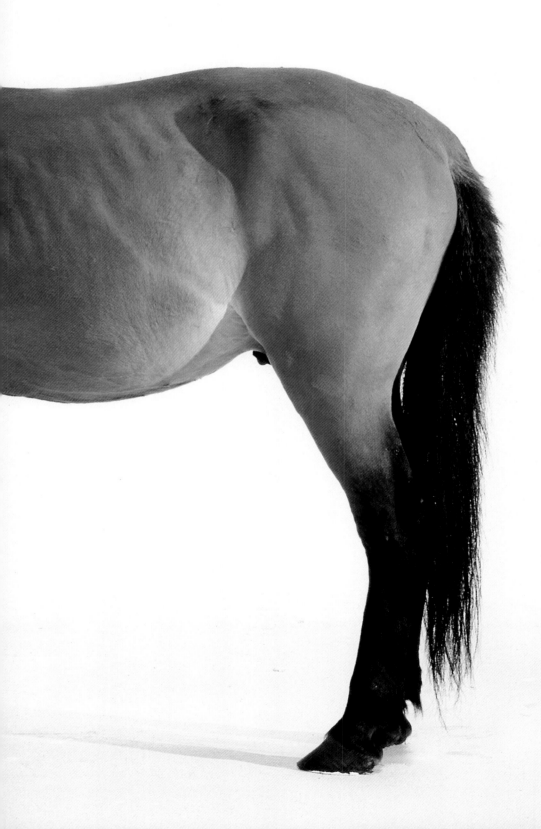

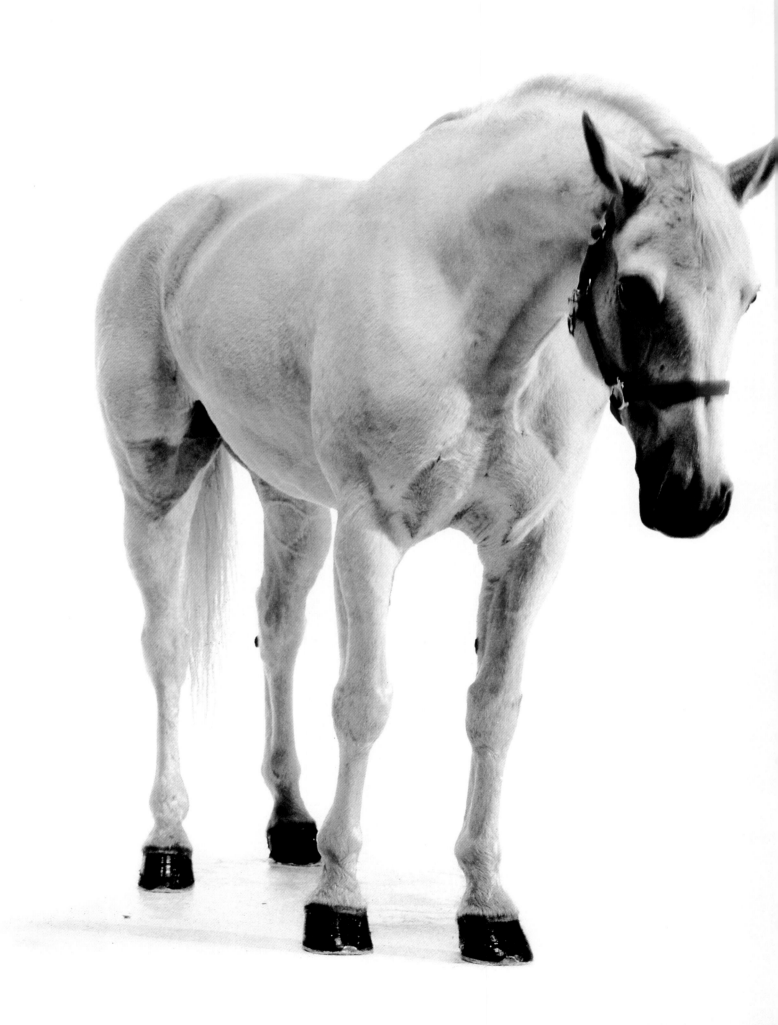

**Przewalski Horse, or Tachi** *(Equus przewalskii)* **Thoroughbred Arab Horse** *(Equus caballus)* Przewalski blood in the veins of an Arab horse? Different chromosome figures suggest a vague, though disputed possibility. The stocky, shy nature of the "primal horse" means it is not appropriate for economic use. Taming it is as difficult as taming a zebra. When threatened, its instinctive reaction is to flee. Out into the wild steppes from which it once came. Much the same as the noble Arabs and the tamest of the almost two hundred different species of domestic horse.

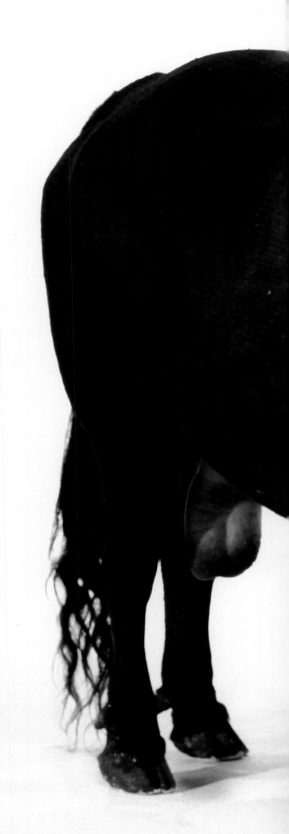

**Domestic Bull** *(Bos primigenius f. taurus)* Anyone who wants to take this bull by the horns will have his hands full! The Italian breeding bull can be justly proud of his equipment. Most of his brothers and sisters will have been dehorned soon after birth, or belong to hornless strains. After all, the breeders are after more milk or beef, not weapons in the byre.

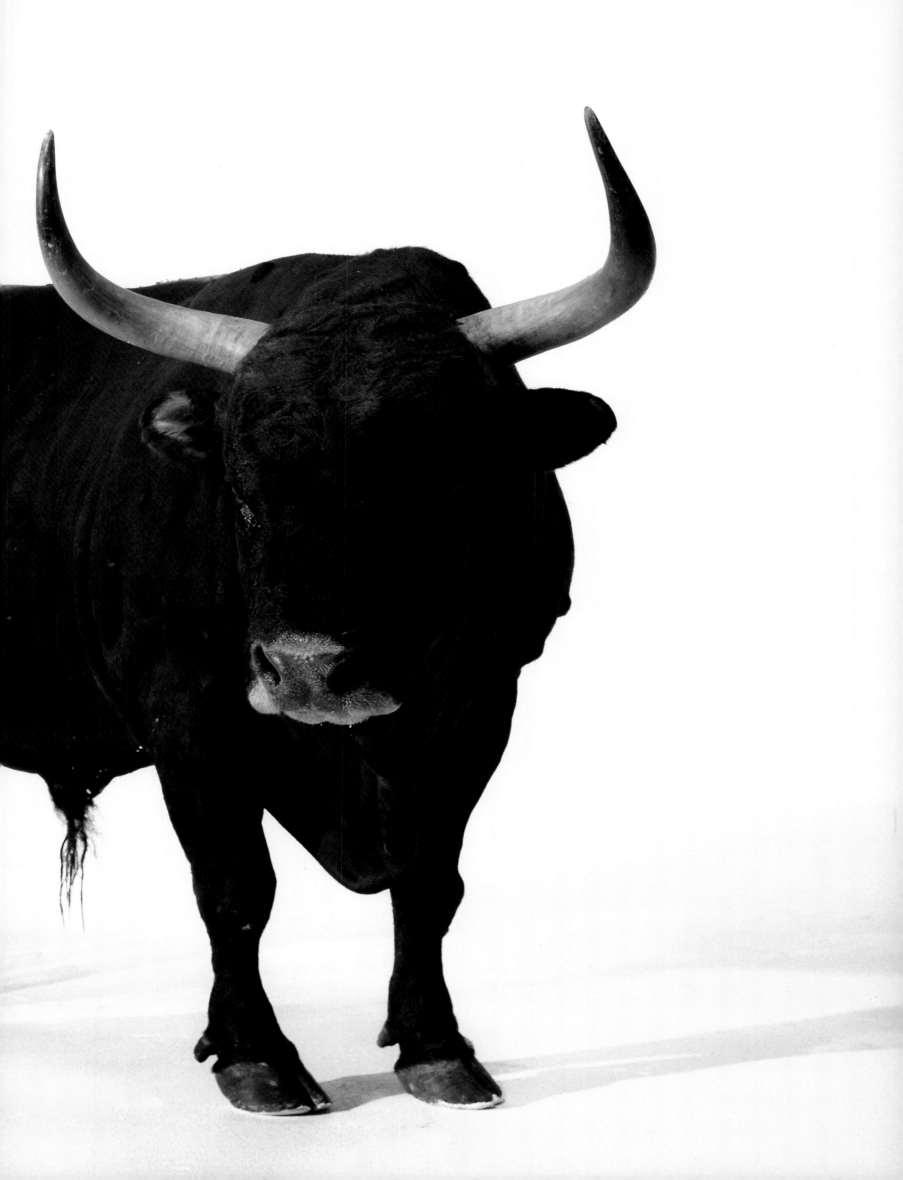

**Raccoon** *(Procyon lotor)* We have no dwarf-elephants. But there are small bears. Somewhat bigger than a garden dwarf, and more closely related to us than one might think. The raccoon hunts in the forests of Alaska, through the USA to Mexico—in shallow pools and rivers, for preference. And whoever in suburbia suspects dogs and cats of rooting through the garbage at night might be wrong. It's the raccoon. Thanks to his dexterity, he enjoys a princely life-style on the fringes of civilization. In American mythology he was always the cunning loner who outwitted us, as he did his opponents. He lurks unnoticed in our shadow, as if we ought to dimly suspect: mankind can not control every inch of the land.

And how cunning he is! A raccoon will find his way into every container, and out of every enclosure. Last year, one traveled in a container from Canada via Hamburg to Pardubice in Bohemia. With a few cans of beer and dog-food he was well provided for on the long voyage. Opening them was no problem for him with those paws and teeth. He has been a legend since ancient times—how he escaped from zoos and farms, how he conquered the forests, untroubled by natural enemies, and returned to the fringes of civilization from where he set out to conquer the continent.

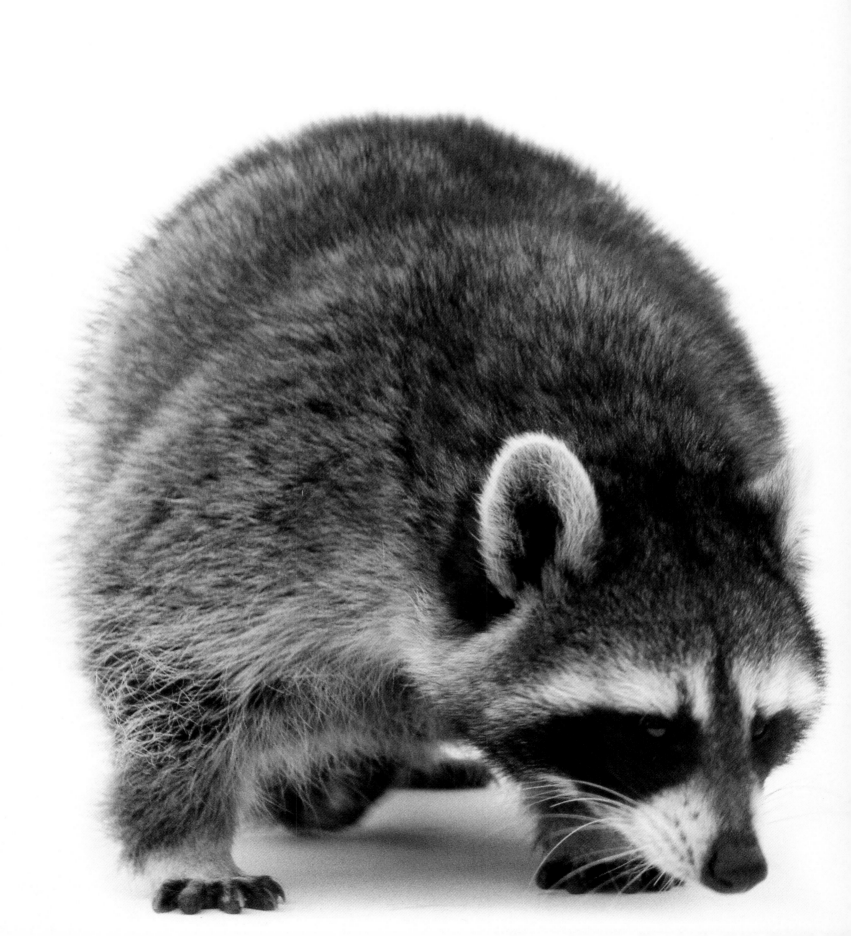

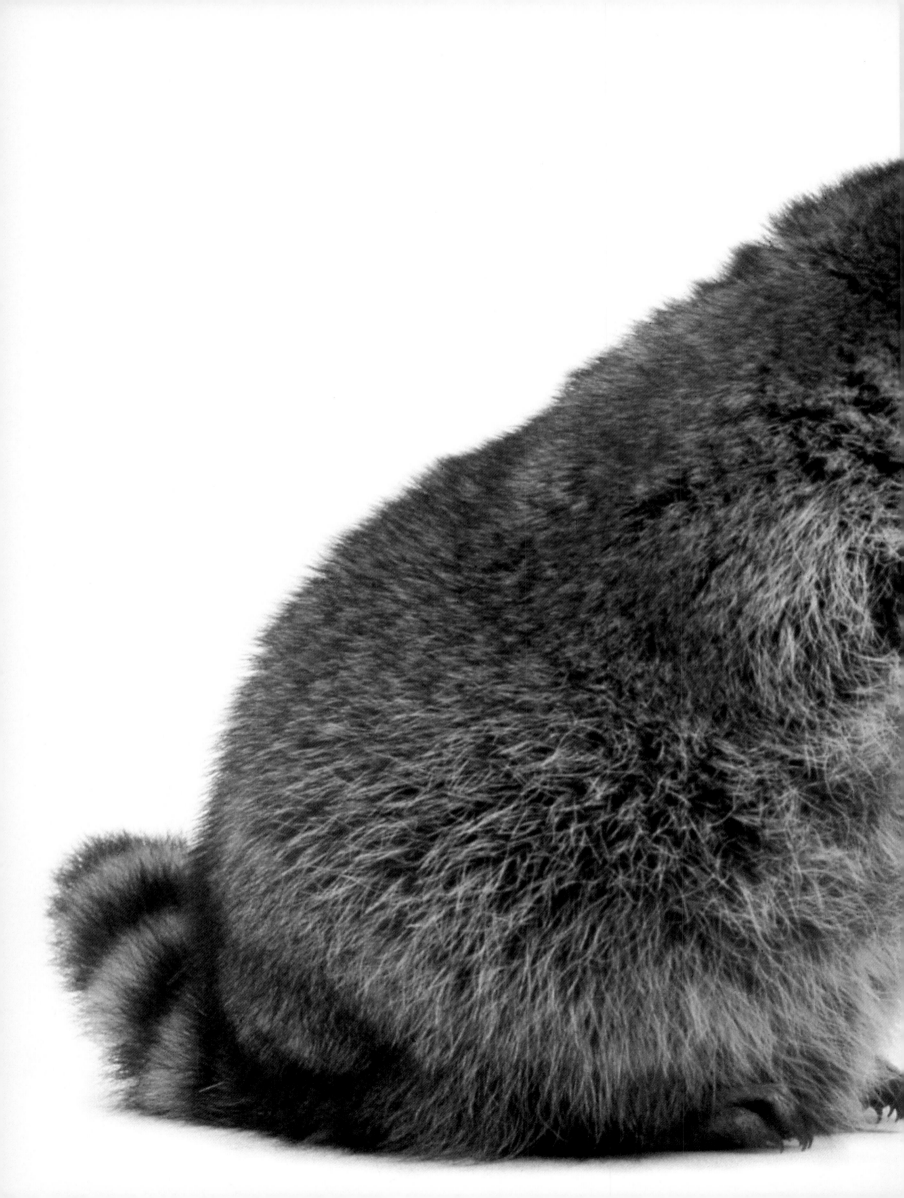

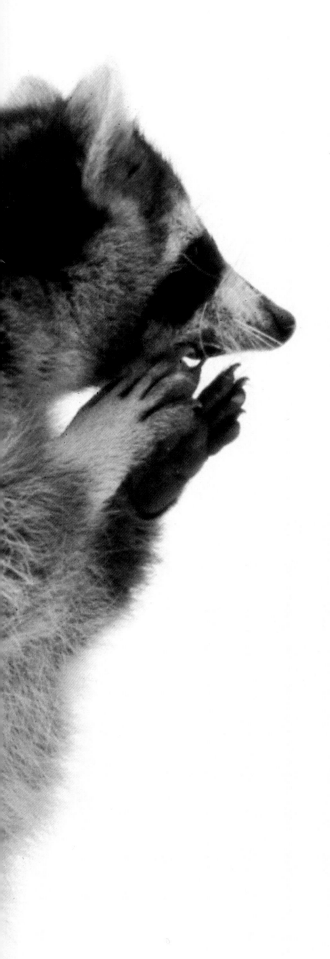

**Raccoon** *(Procyon lotor)* Why do Germans call him a "wash-bear" *(Waschbär)*? Because he washes his food before he eats it. But what one sees in the zoo is not really washing, but a form of atavism—a throwback to his origins. With his fine-nerved fingers he used to hunt crabs and small fish in his pools. He has never been able to forget the wonderful feeling of getting his food fresh from the water.

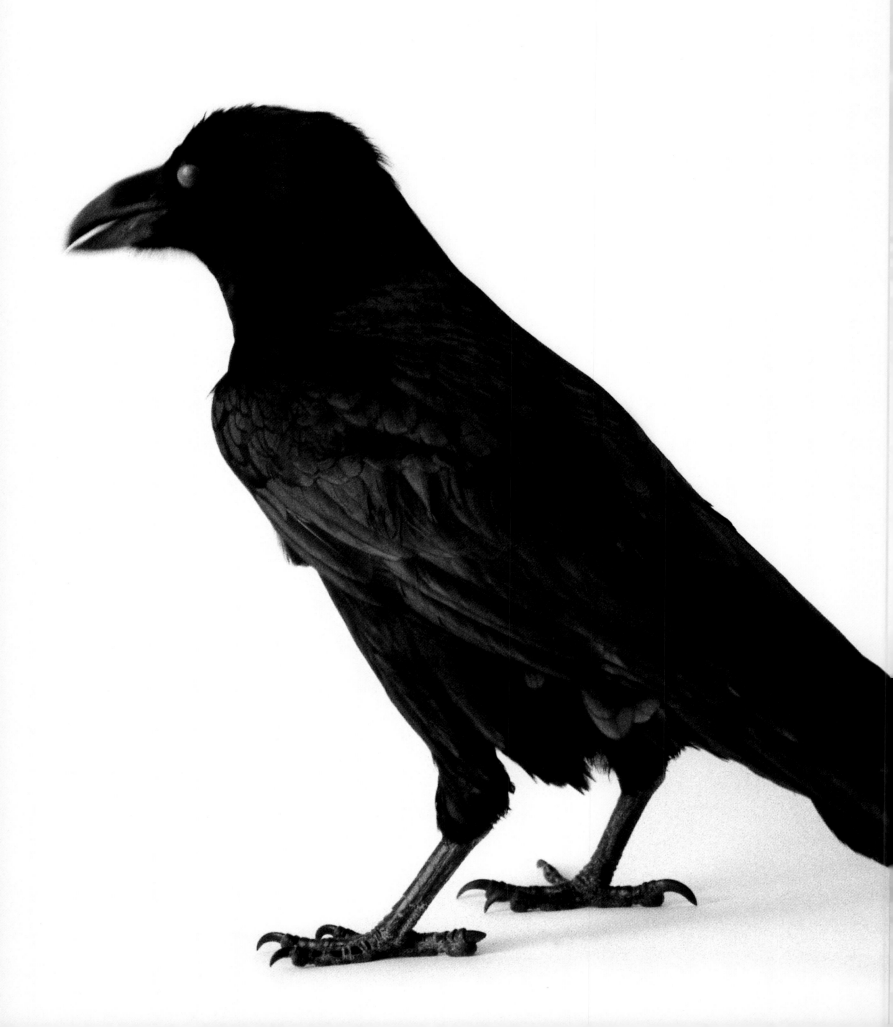

**Raven**  *(Corvus corax)*  It was the raven, the gallows-bird, companion of witches. Whoever doesn't behave will get turned into one. Hacks out the eyes of corpses on the gallows. Hardly anyone has ever seen a raven do this, but its image belongs in the collective memory of mankind. Wherever a raven settles, he brings bad luck into the house—particularly if he appears in a flock. Together with sea-gulls Alfred Hitchcocks's *The Birds* terrify people.

**Red Deer** *(Cervus elaphus)* "Bambi," you immediately think, and reach for the paper handkerchiefs. Don't worry. Anyone who knows Felix Salten's story and Walt Disney's film would do the same. But just to keep you in the picture, that sweet little fawn is neither a roe deer nor the young of one, but a young white-tailed stag. And to make matters even more complicated: it is the red deer calf which is here destined to be "King of the forest." You can judge the size of the male of the species from those colorful wall decorations in the living-room of Mr. Average with his dreams of power and freedom: "the roaring deer" with the impressive antlers is the dominant stag defending his harem, or his insolent rival challenging him to a duel. The victor then sires the "Bambis." The American subspecies, the huge wapiti, emits a high squeaky cry instead of a deep sonorous bellow.

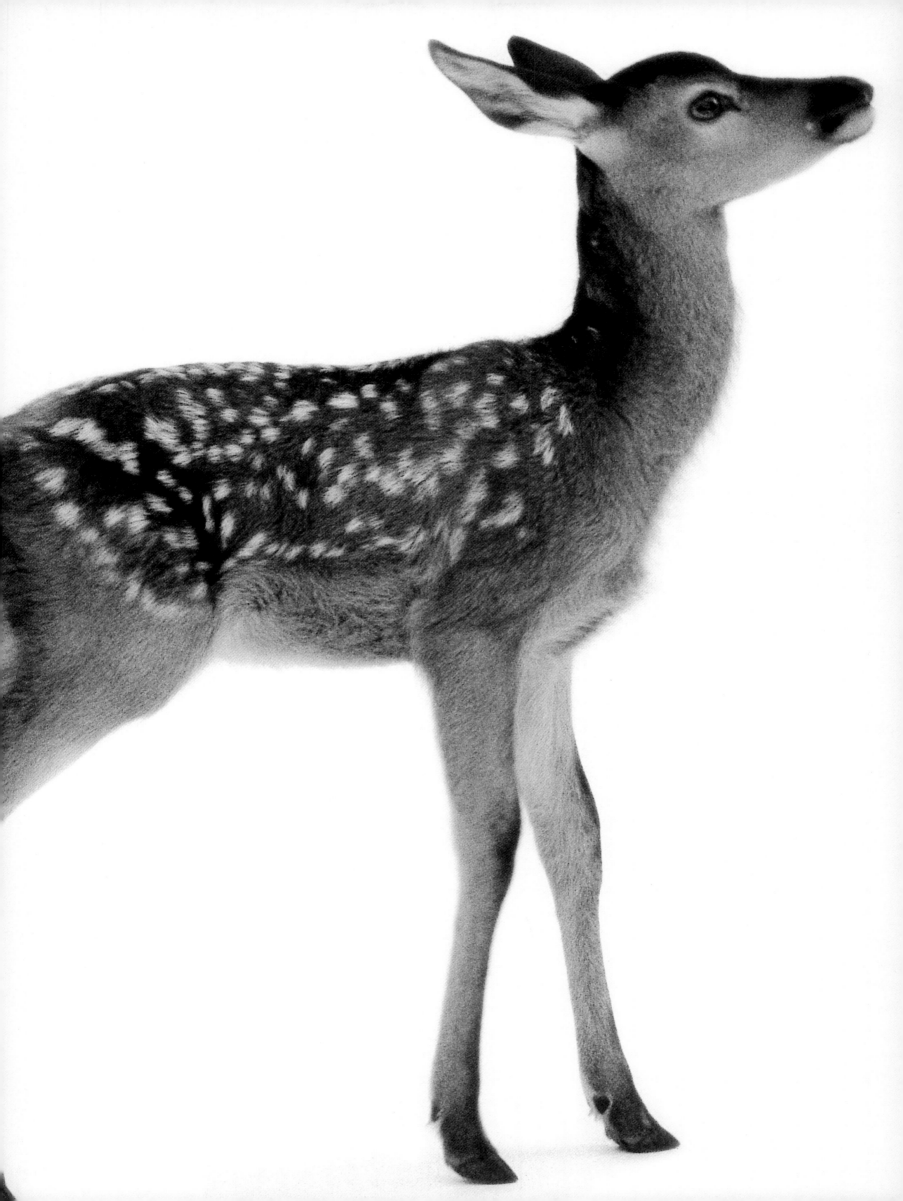

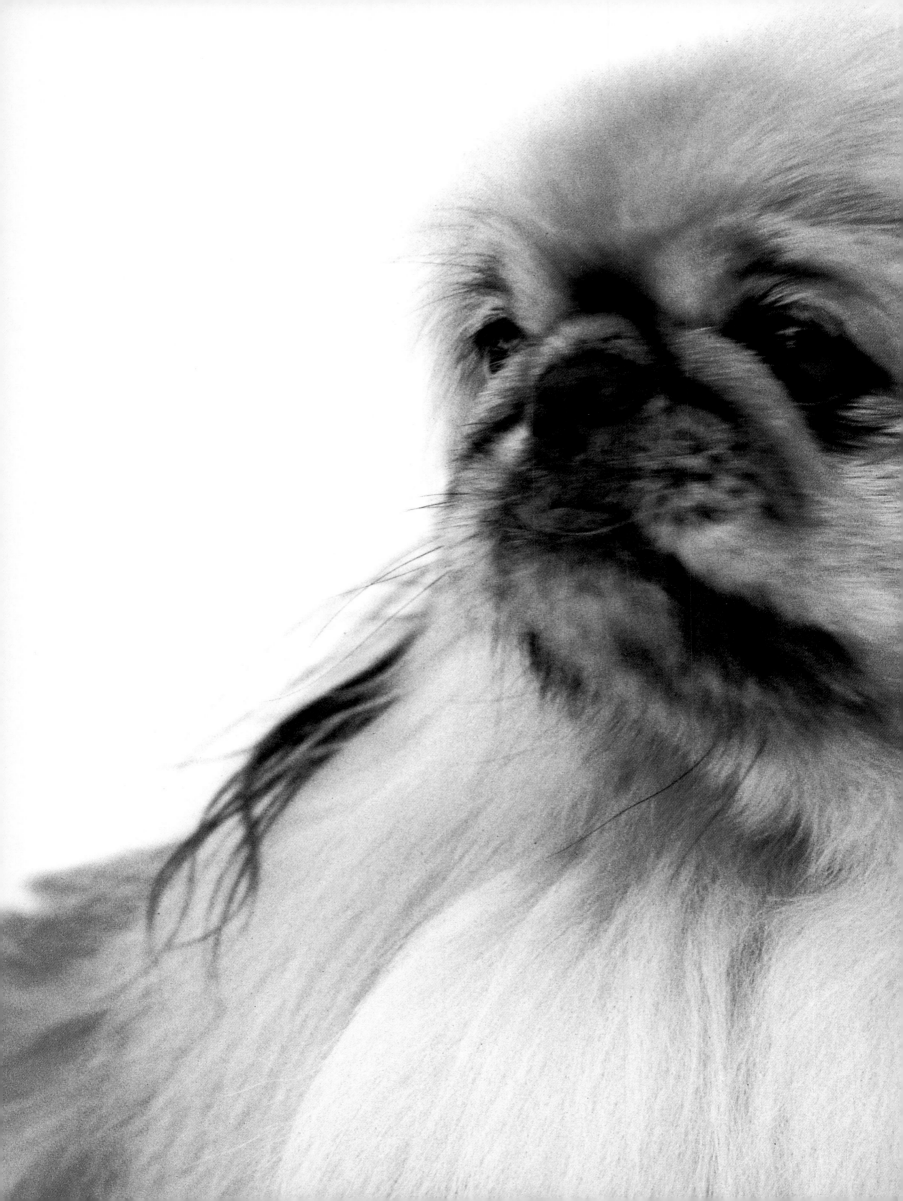

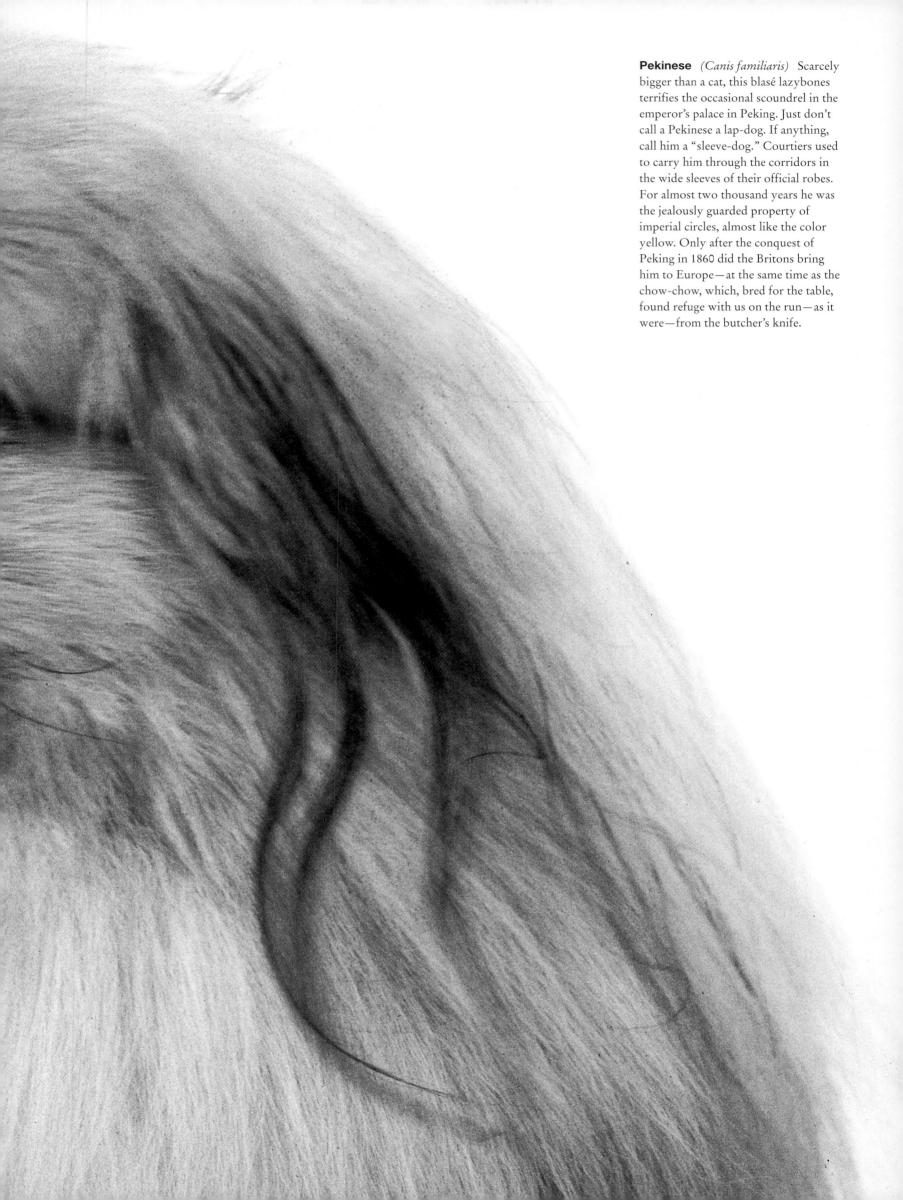

**Pekinese** *(Canis familiaris)* Scarcely bigger than a cat, this blasé lazybones terrifies the occasional scoundrel in the emperor's palace in Peking. Just don't call a Pekinese a lap-dog. If anything, call him a "sleeve-dog." Courtiers used to carry him through the corridors in the wide sleeves of their official robes. For almost two thousand years he was the jealously guarded property of imperial circles, almost like the color yellow. Only after the conquest of Peking in 1860 did the Britons bring him to Europe—at the same time as the chow-chow, which, bred for the table, found refuge with us on the run—as it were—from the butcher's knife.

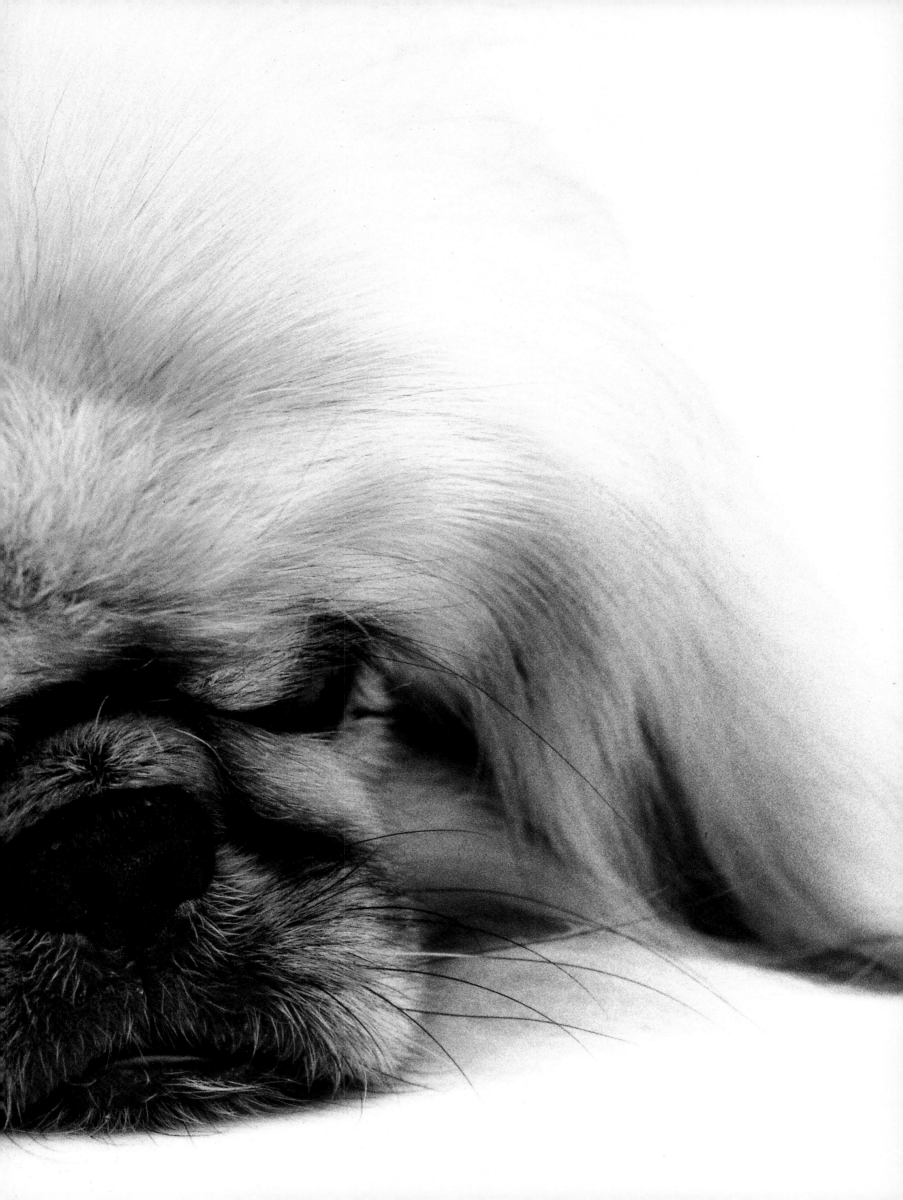

**Canary** *(Serinus canaria)* What bird plays a role in Mozart's *Magic Flute?* Right. Papageno may call himself a fowler, but he buys his goods in the Tyrol. The canary bears vocal witness to a piece of industrial history. Originating on the Canary Islands, certain breeds of the serin conquered European silver mines, first in the Tyrol, then in the Harz mountains in Germany. The miners projected their dreams onto the delicate little singers—and began to breed them, hoping to become bird wholesalers. Around 1880, Papageno's sophisticated heirs sent hundreds of thousands of birds to the United States. From the first tones a connoisseur can immediately recognize whether the bird courting the favors of his distant loved-one is a "Harz roller," a pedigree roller or a Belgian water warbler. They all have different dialects and bequeath countless melodies to their offspring to take with them into the loneliness of their cages. "Good luck!" as the miners say. By the way, sorry not to mention the female, but the fact is that the male is the more melodious singer.

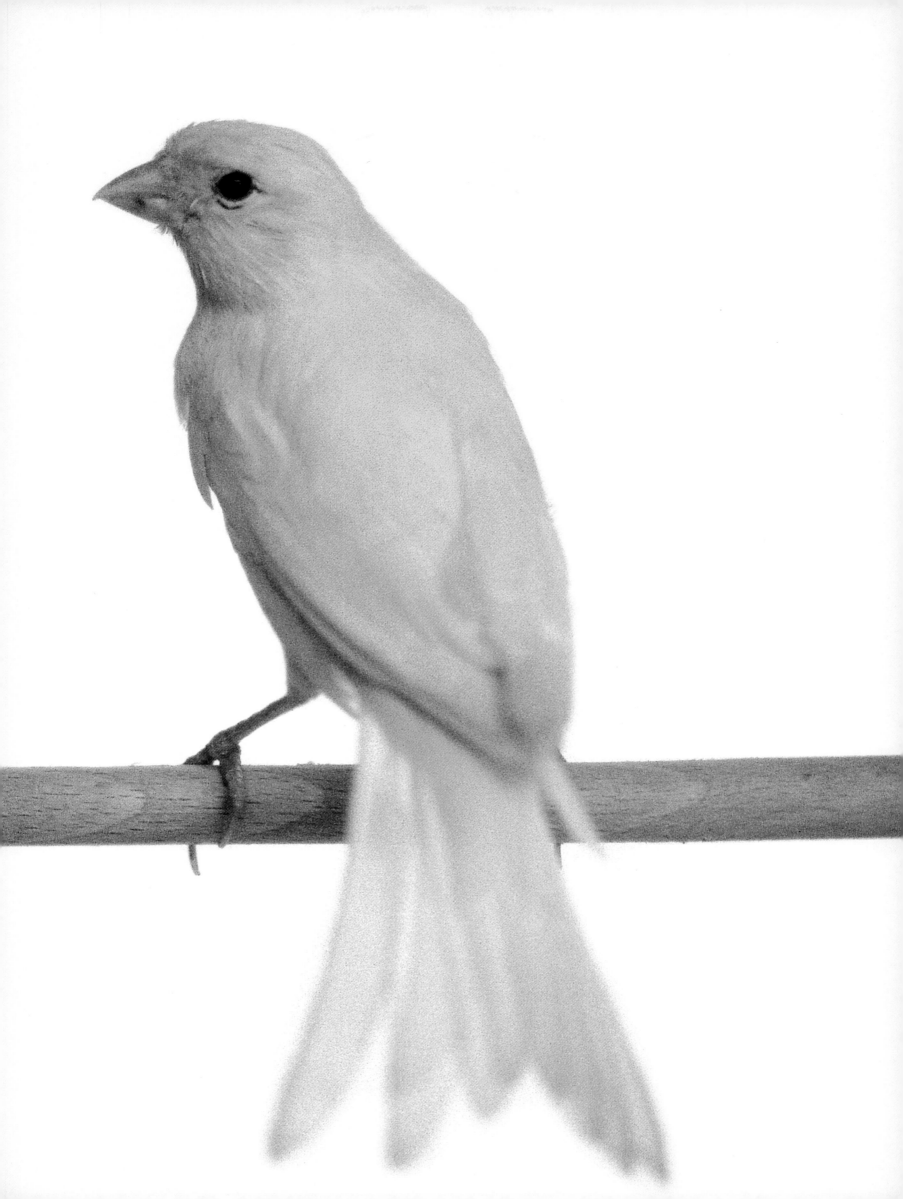

**Greyhound** *(Canis familiaris)* So this is what unites America's towns and villages "from San Diego up to Maine." Bred in ancient Egypt to hunt gazelles, pampered in English castles to hunt hares to the death in coursing meetings, he has become in his own way a victim of mechanization.

It is not really fair to have him chase round a race-track after a mechanical hare simply for the money — a lot of money, one hears it said again and again by critics of the sport he so loves. But what does he care about the genuineness of the hare? He holds his head high because he hasn't got a particularly good sense of smell. The speed junkie just likes running. Sets off after anything that moves. It's that simple. With far less than one horse-power at his disposal, he always gets to the line first. Just after the hare. Run, greyhound, run!

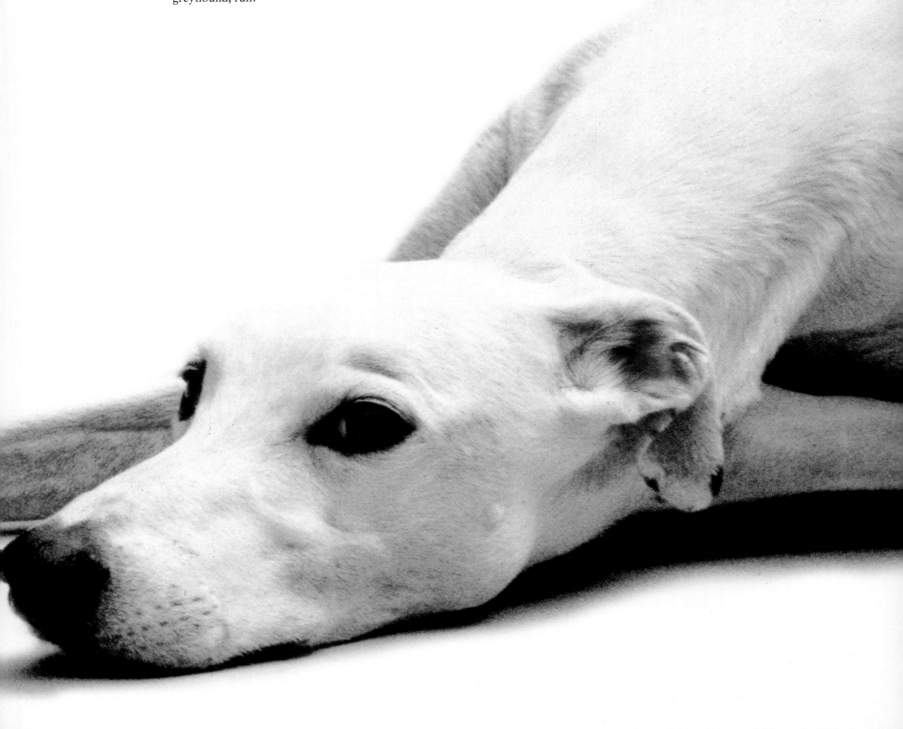

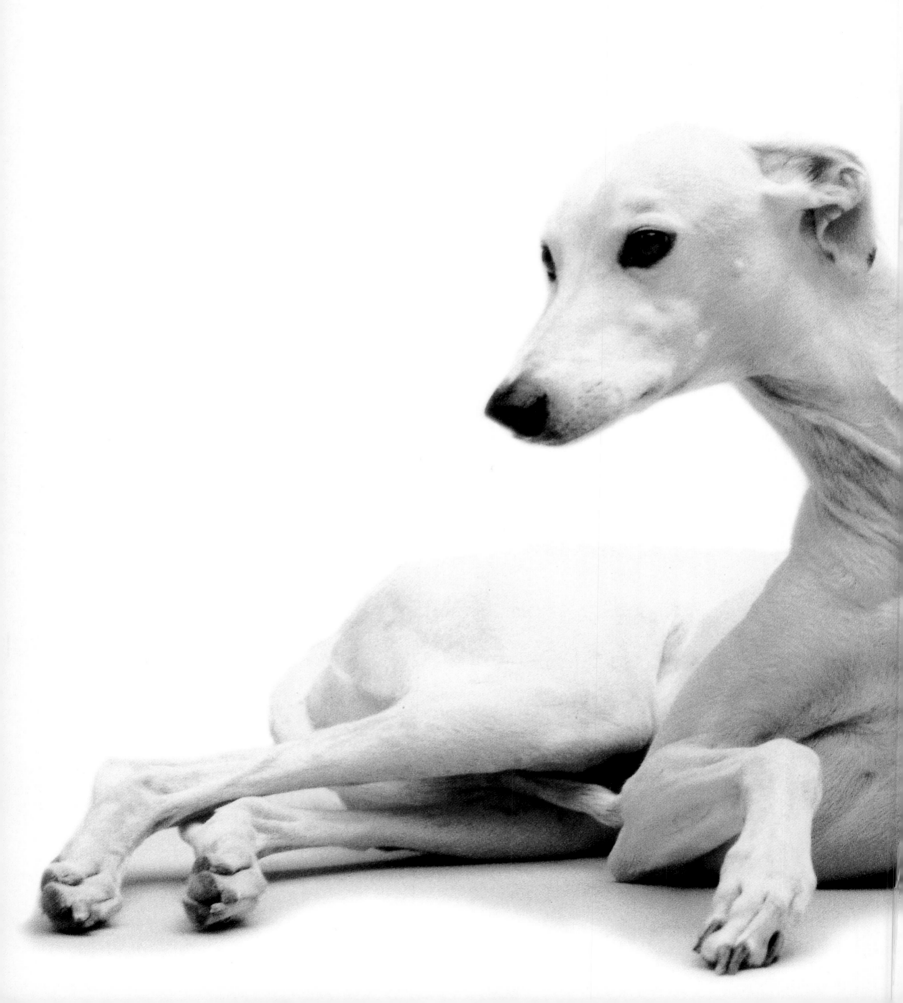

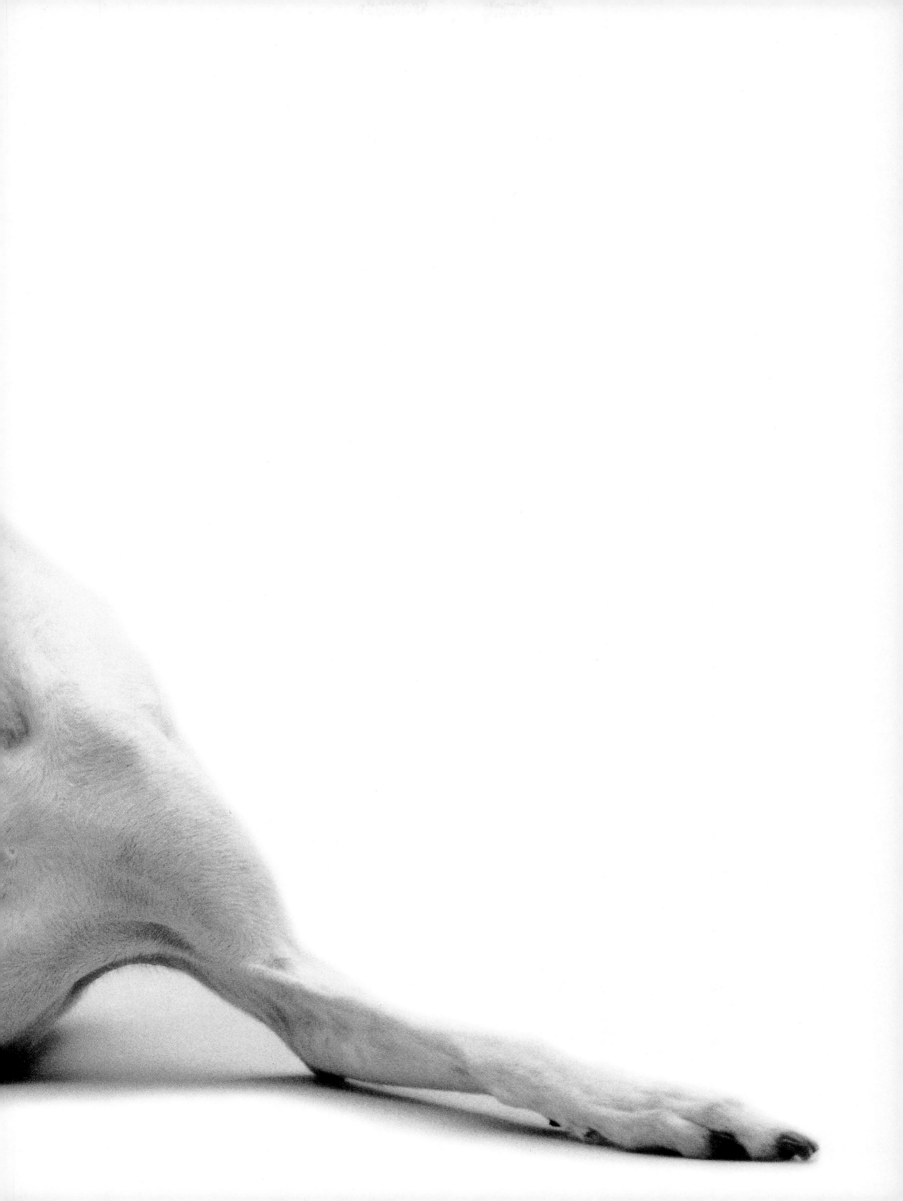

**Shi Tzu Terrier** *(Canis familiaris)*

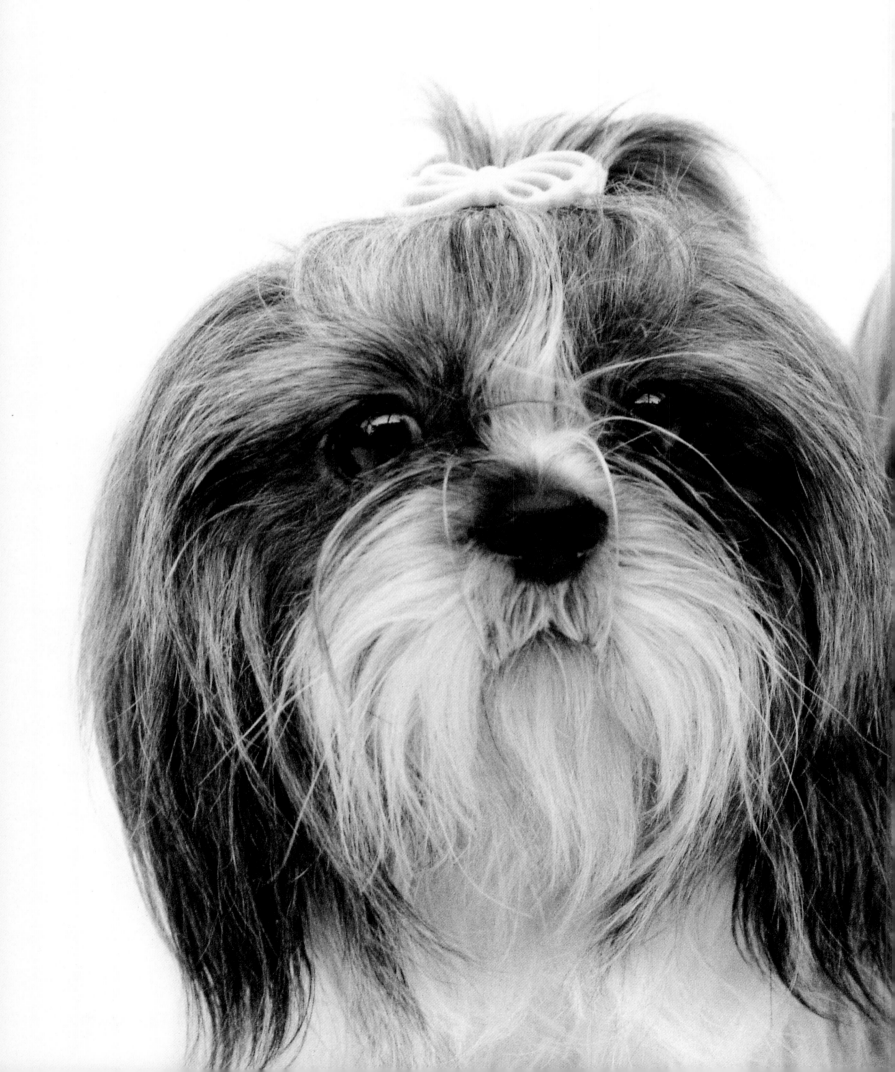

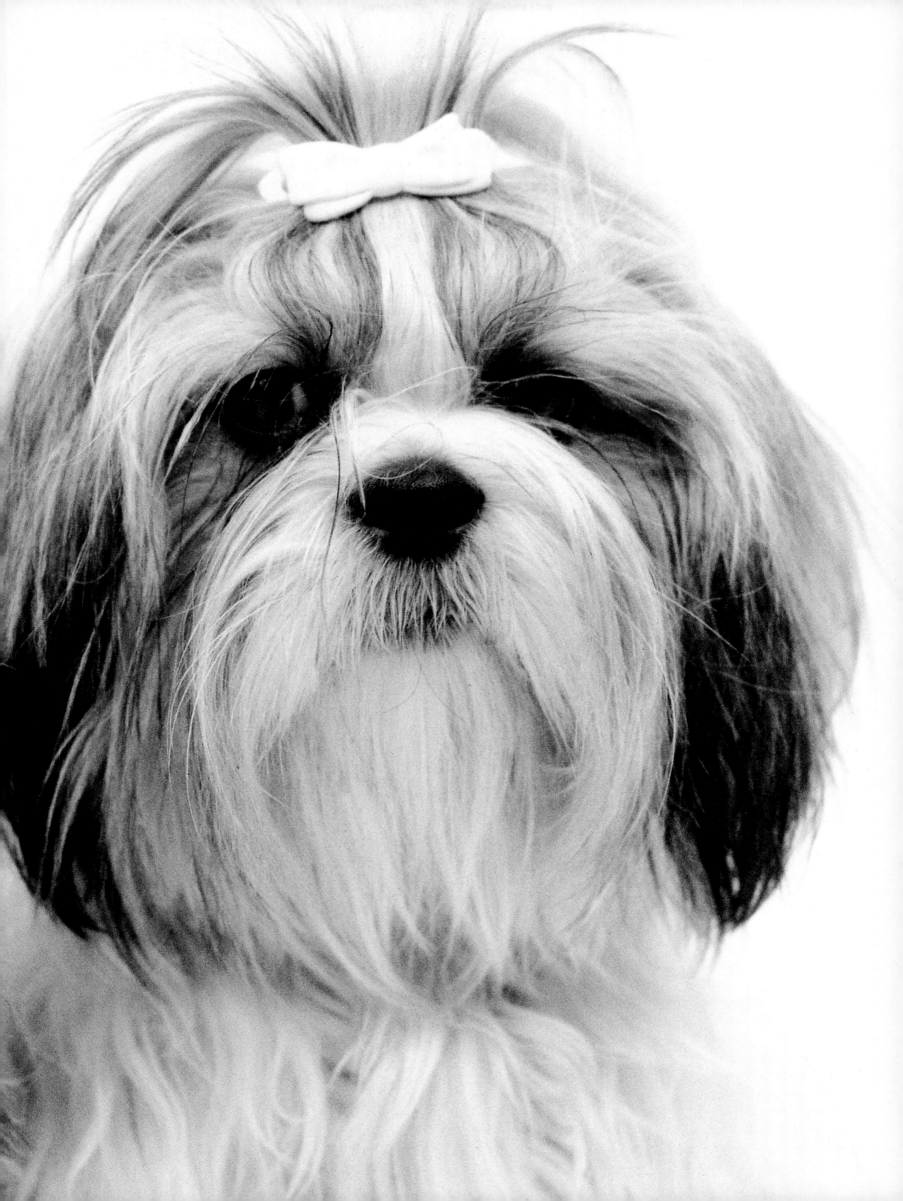

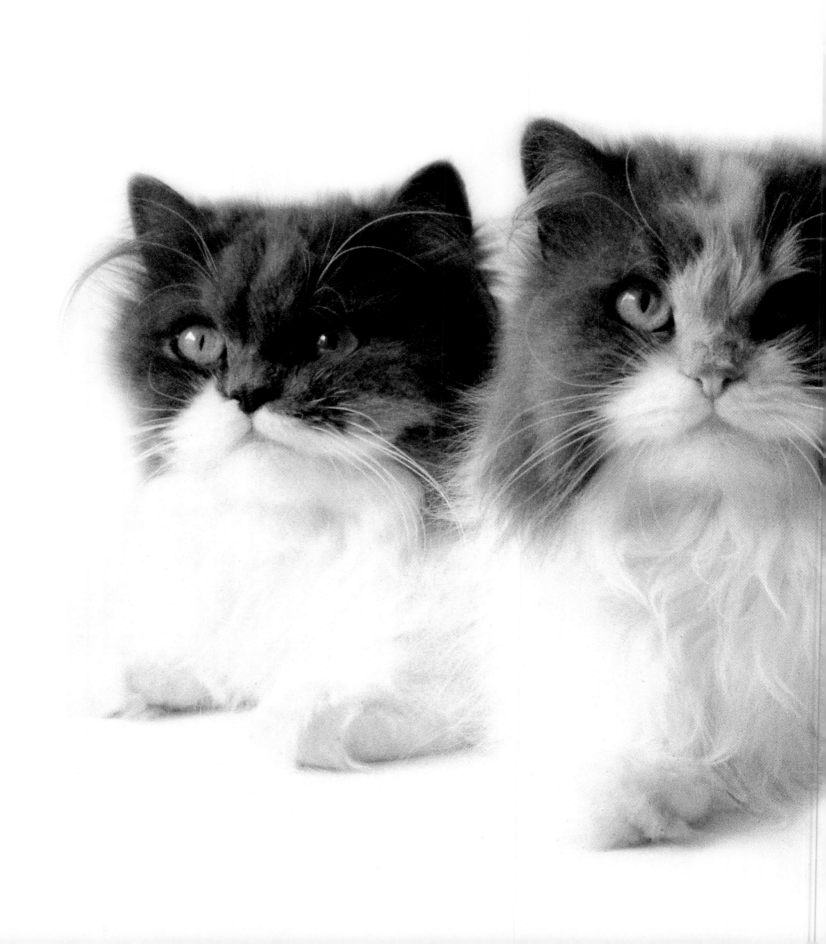

**Persian Cat** *(Felis catus domestica)* Genuine Persian cats have names like Julius Caesar of Elfin Valley, Betty Boo of Shaded Pearls, or Amiga de la Motta. The Persian cat is proud of its noble roots; these got lost somewhere between Ankara and China, but live on in the names. Dealing with the legacy of long selective breeding is no easy matter. And as if lamenting their fate, many of them battle with constant weepy eyes, due to their short nose. Mice, though, would be well advised not to come too close.

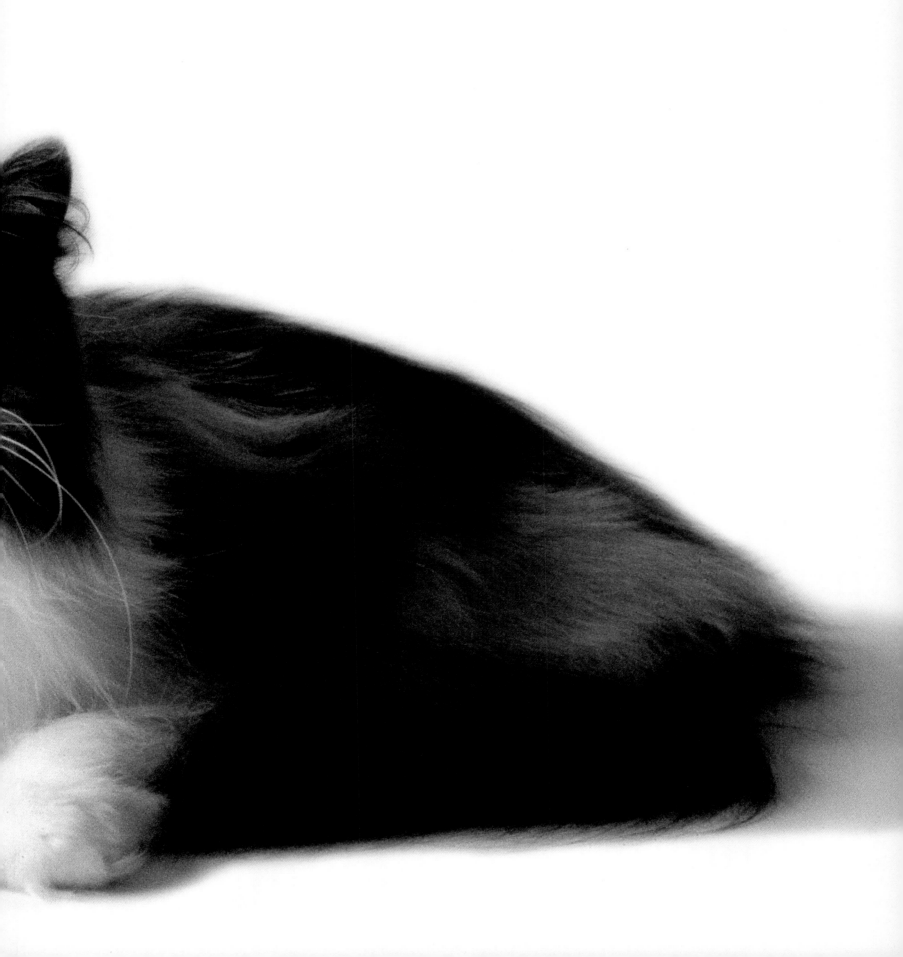

**Flamingo**  *(Phoenicopterus sp.)*  The feathered wedding invitation: two flamingos in perfect harmony. Since the advent of *Art Nouveau* at the latest, flamingos are supposed to embody erotic decadence. But the gay clubs, publishers of erotica and beach hotels of the same name have little in common with the real life flamingo. These filter tiny creatures out from the surface of the pools which dot their breeding grounds in their thousands, with their beaks. The seductive pink of their plumage comes from carotene in their main diet. If they fed on something different, we would certainly not find them as exotic as we do.

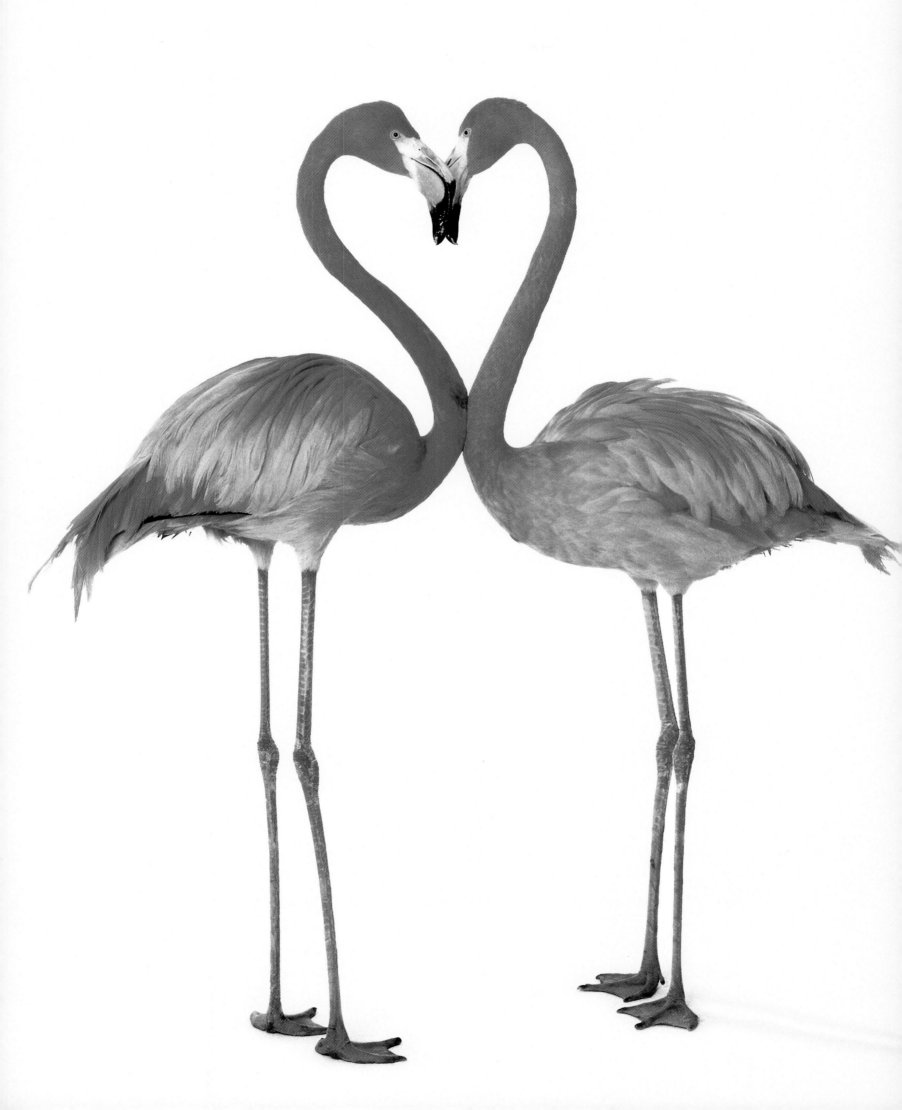

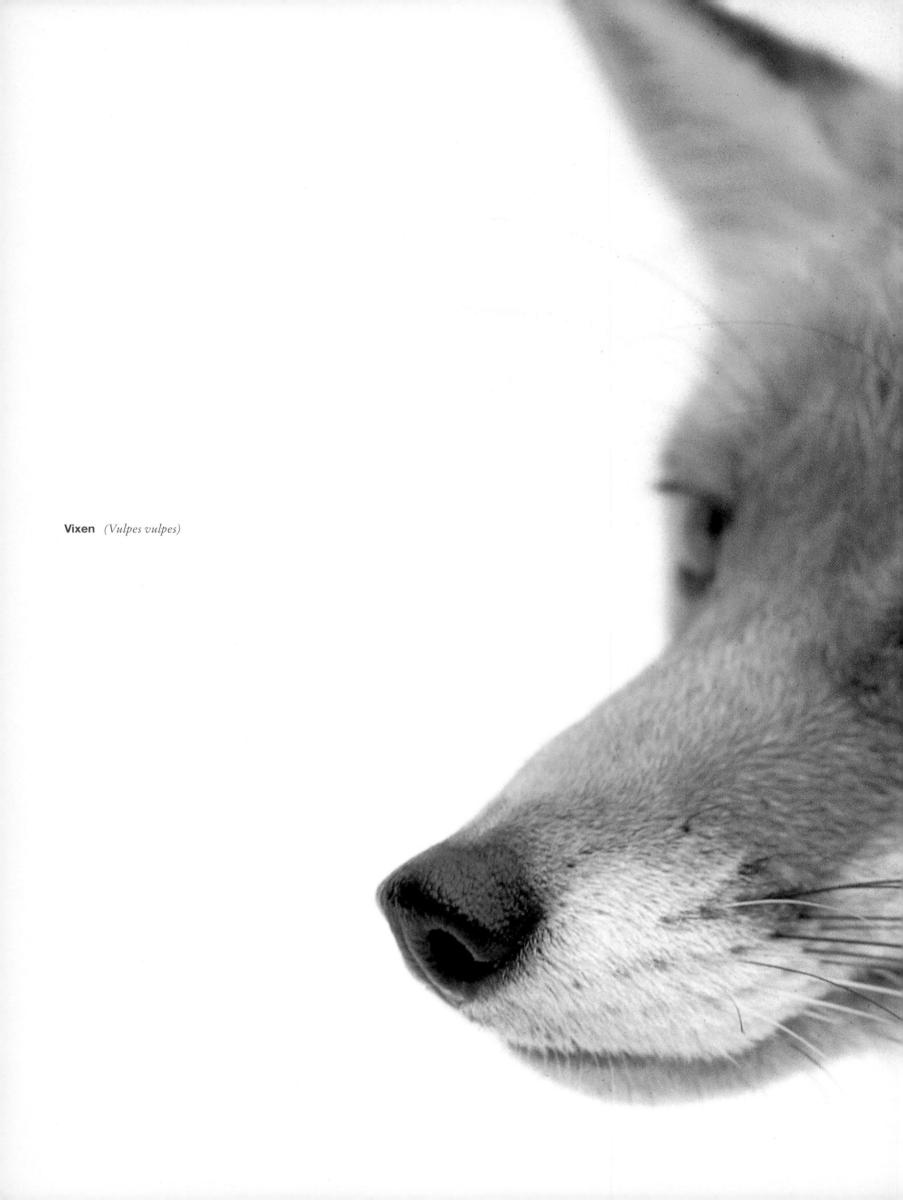

**Vixen**  *(Vulpes vulpes)*

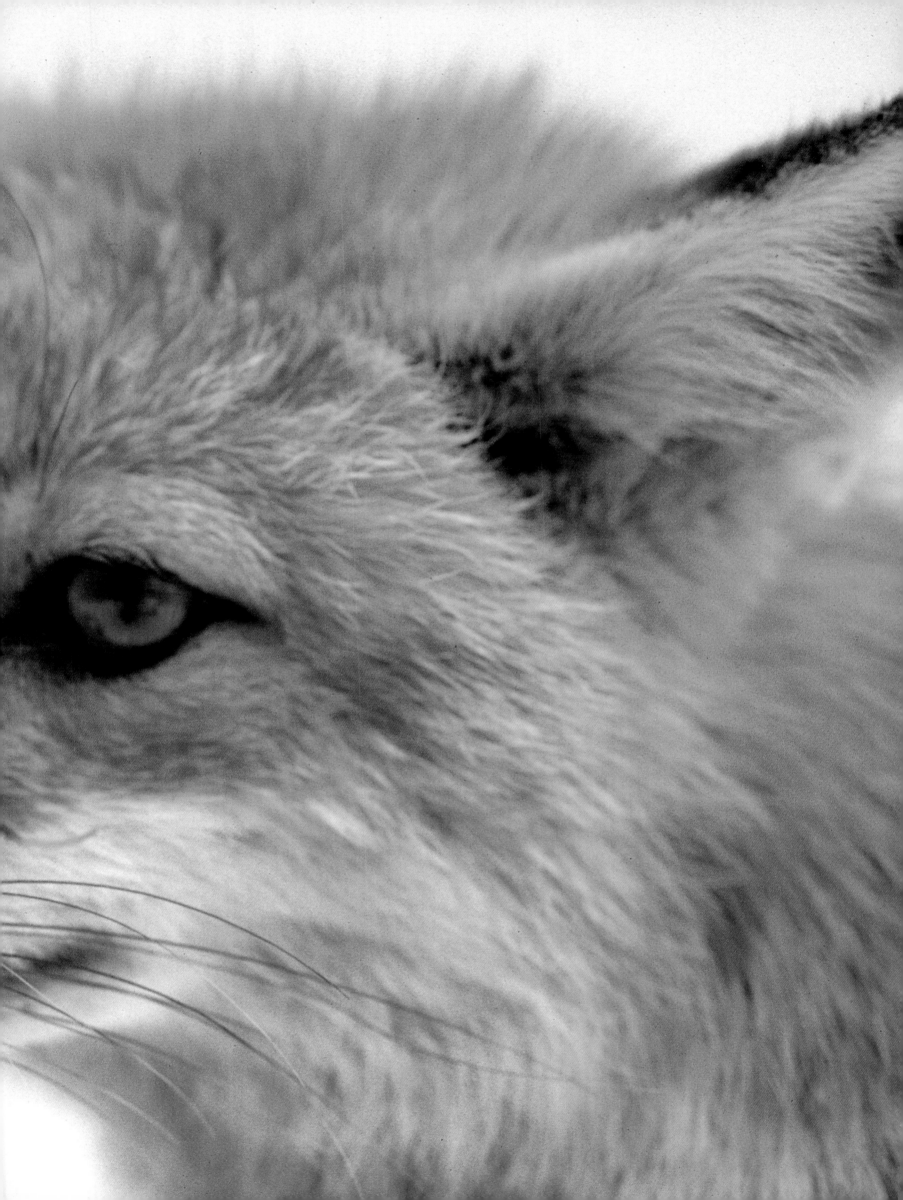

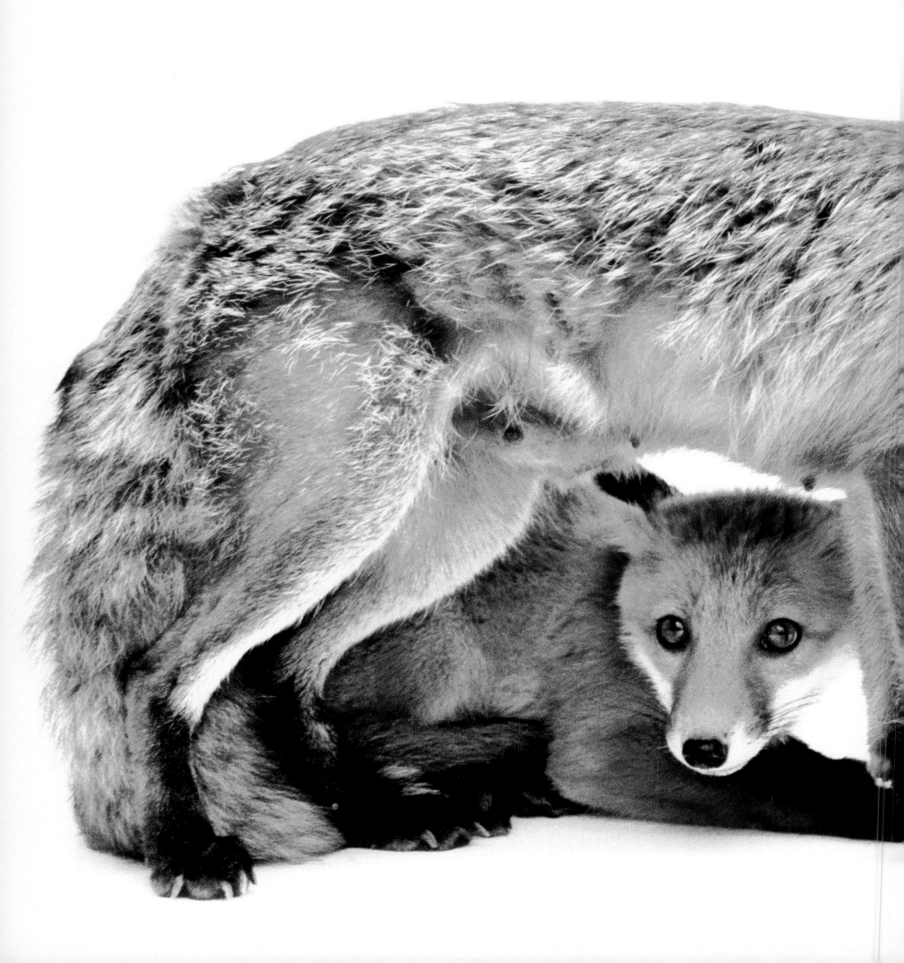

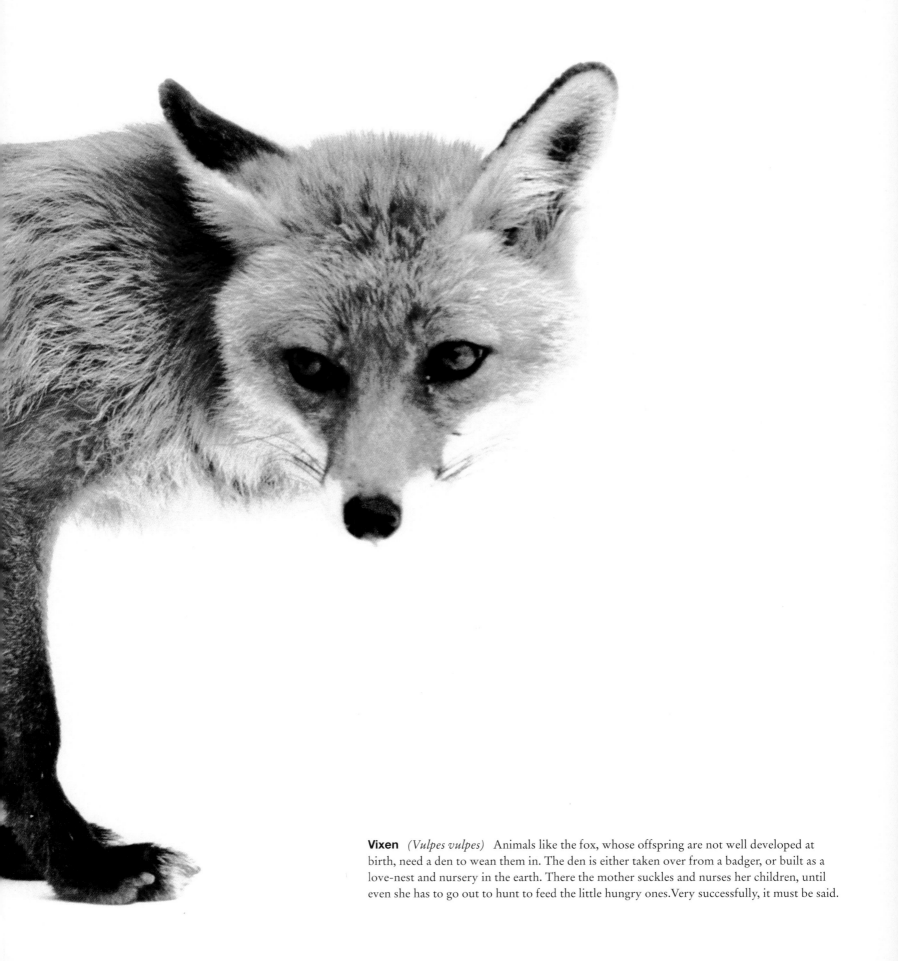

**Vixen** *(Vulpes vulpes)* Animals like the fox, whose offspring are not well developed at birth, need a den to wean them in. The den is either taken over from a badger, or built as a love-nest and nursery in the earth. There the mother suckles and nurses her children, until even she has to go out to hunt to feed the little hungry ones. Very successfully, it must be said.

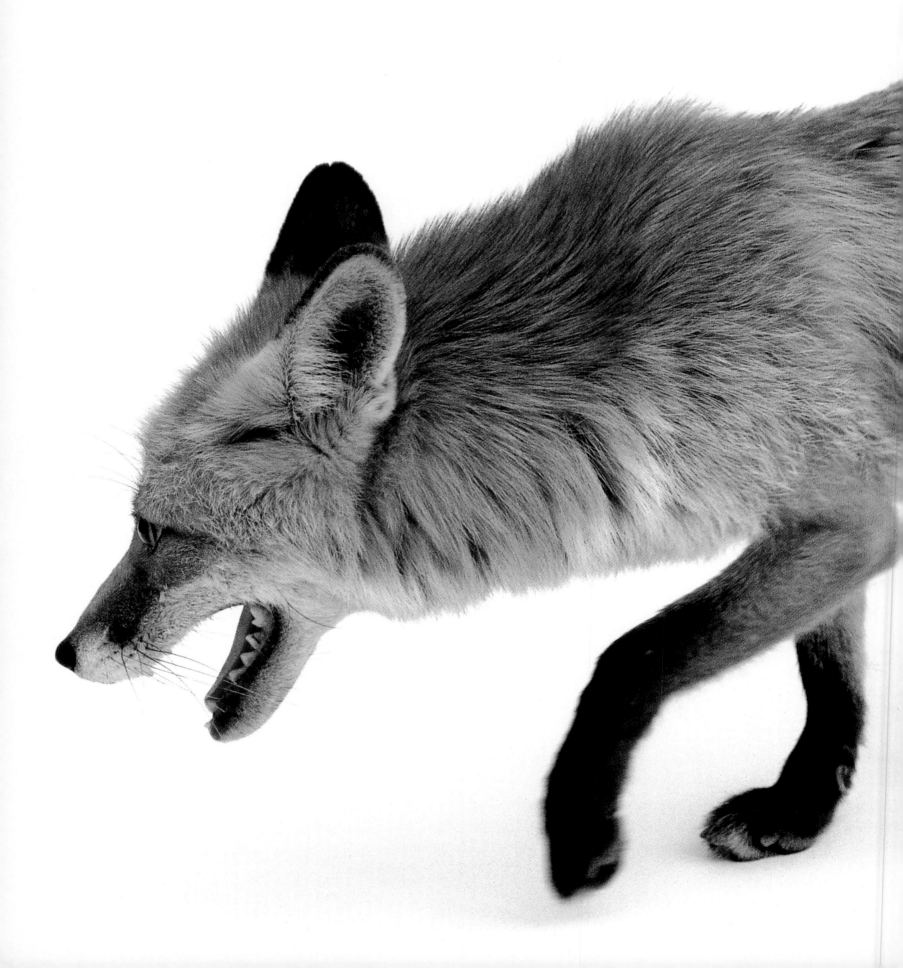

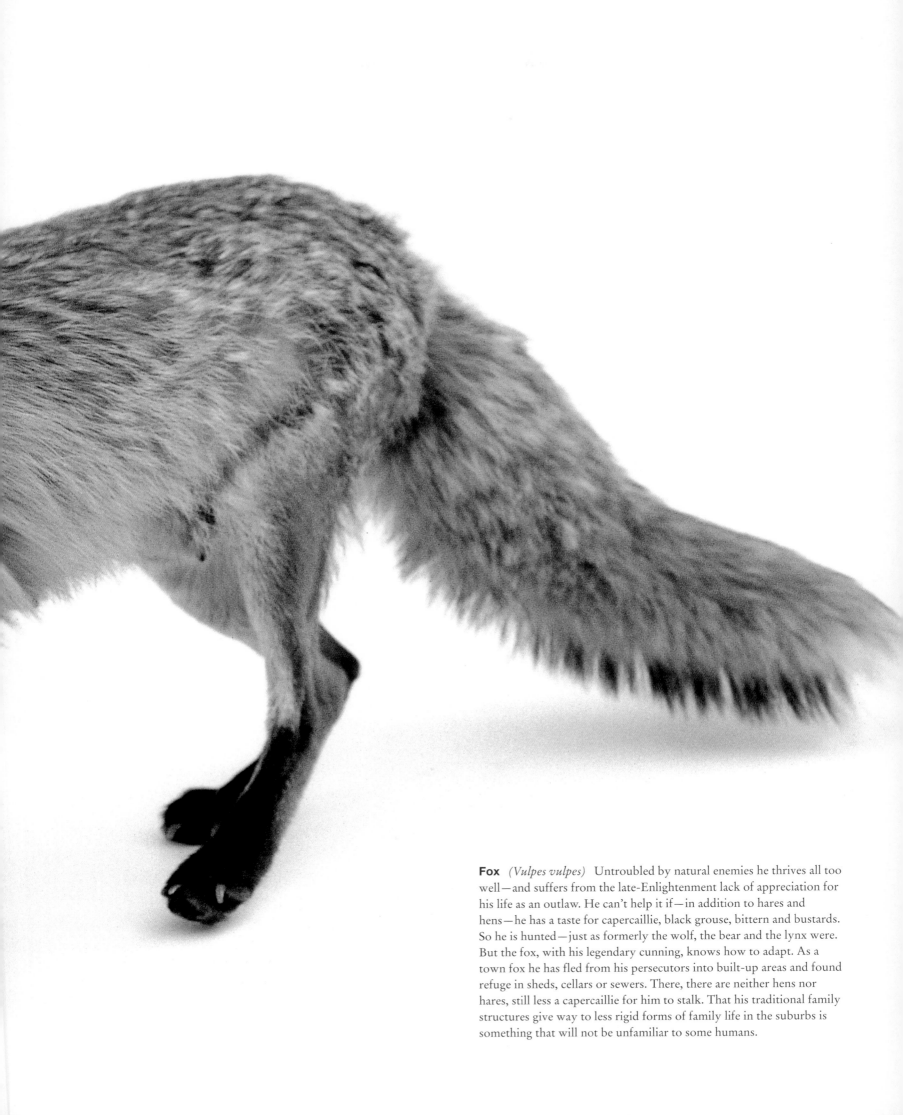

**Fox** *(Vulpes vulpes)* Untroubled by natural enemies he thrives all too well—and suffers from the late-Enlightenment lack of appreciation for his life as an outlaw. He can't help it if—in addition to hares and hens—he has a taste for capercaillie, black grouse, bittern and bustards. So he is hunted—just as formerly the wolf, the bear and the lynx were. But the fox, with his legendary cunning, knows how to adapt. As a town fox he has fled from his persecutors into built-up areas and found refuge in sheds, cellars or sewers. There, there are neither hens nor hares, still less a capercaillie for him to stalk. That his traditional family structures give way to less rigid forms of family life in the suburbs is something that will not be unfamiliar to some humans.

**Marmot** *(Marmota marmota)* They sleep through Christmas and Easter. Rolled up in a ball like hedgehogs, the whole colony in the same sett—twelve, fifteen of them, the smallest in the middle,—they let cold and tempest pass over them unnoticed. The organism is set at "low." Only about five heartbeats a minute, a breath drawn every ten to twelve minutes, and the body temperature sunk to four degrees above zero. Poachers pull them out of their nests as if they were dead—for their fur, for the meat, and above all for the fat, the wonder-cure which helps the true mountain-climber for and against everything. This one here, however, managed to save its skin, and everything else with it. The summer is short: enjoy it while it lasts.

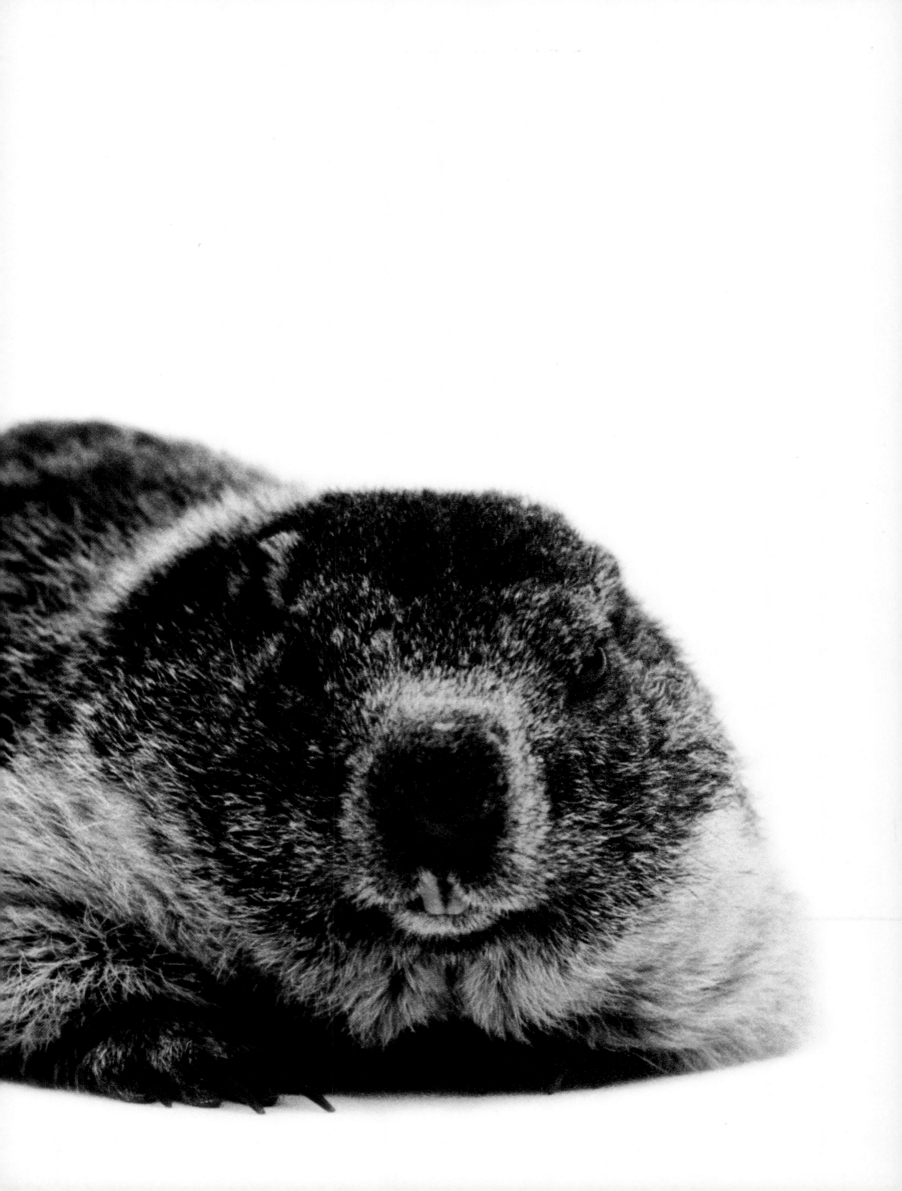

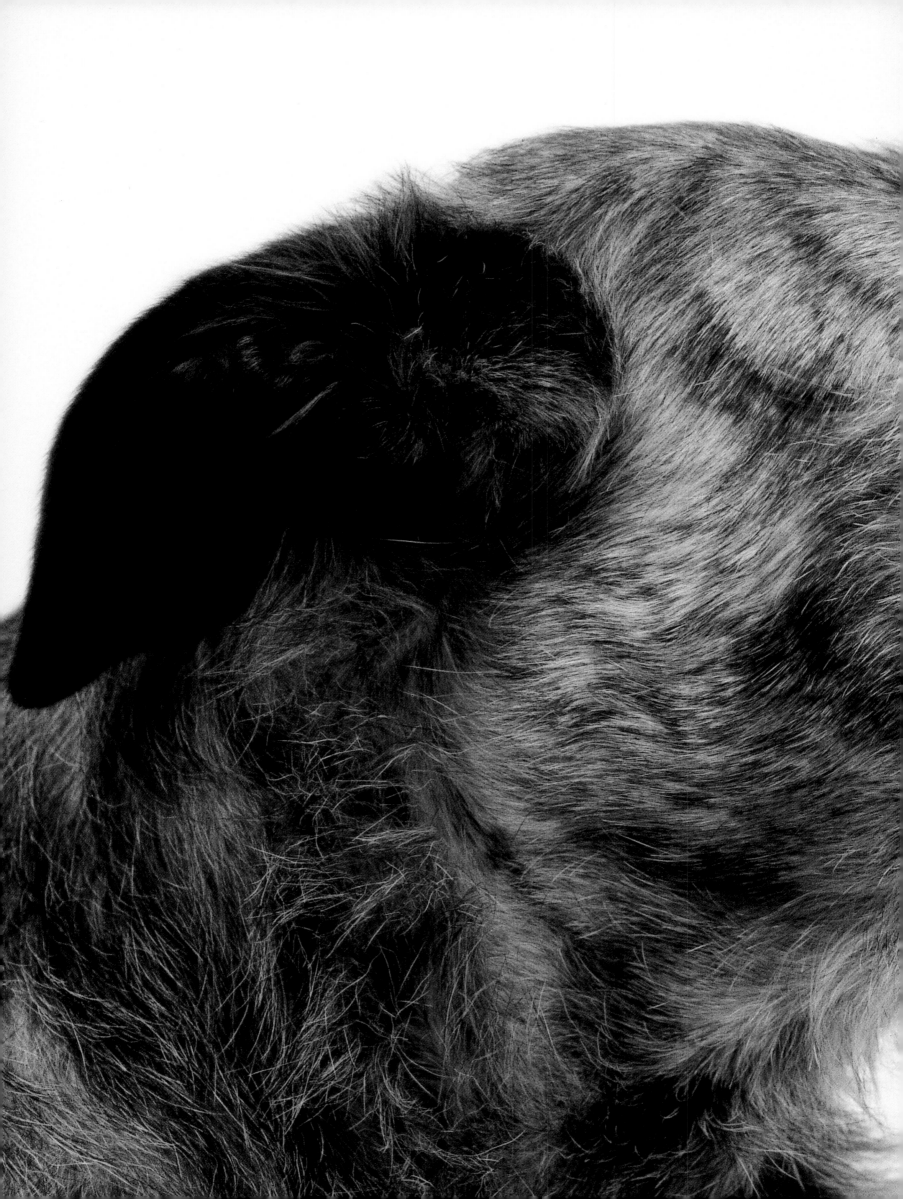

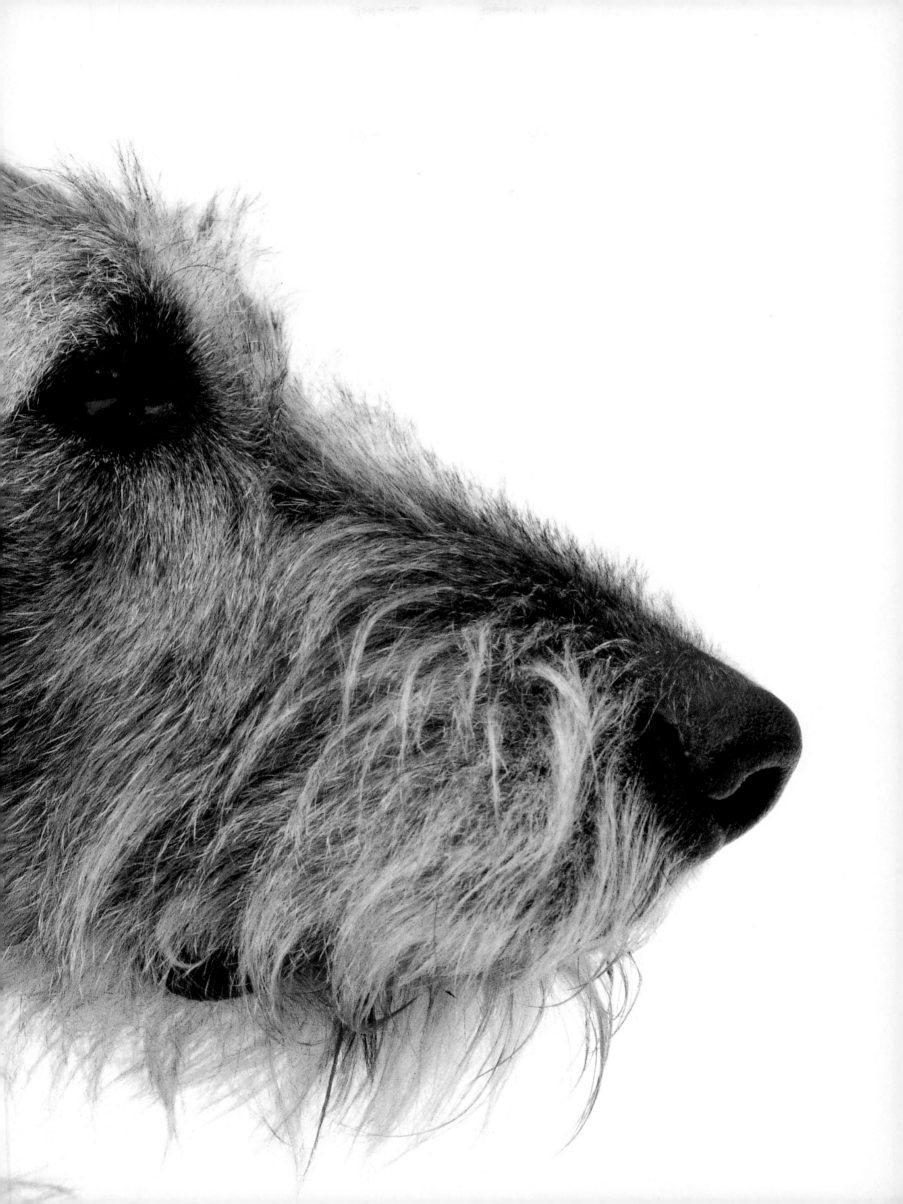

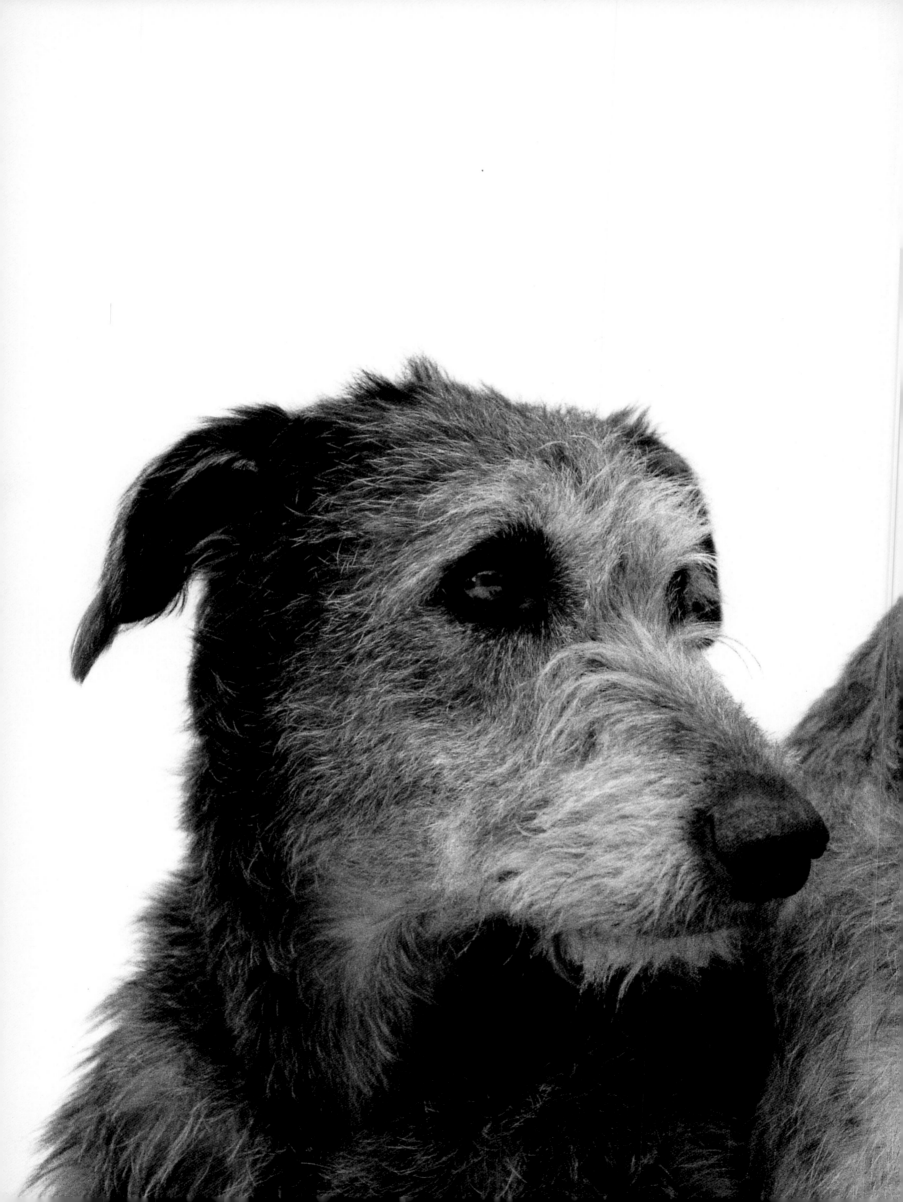

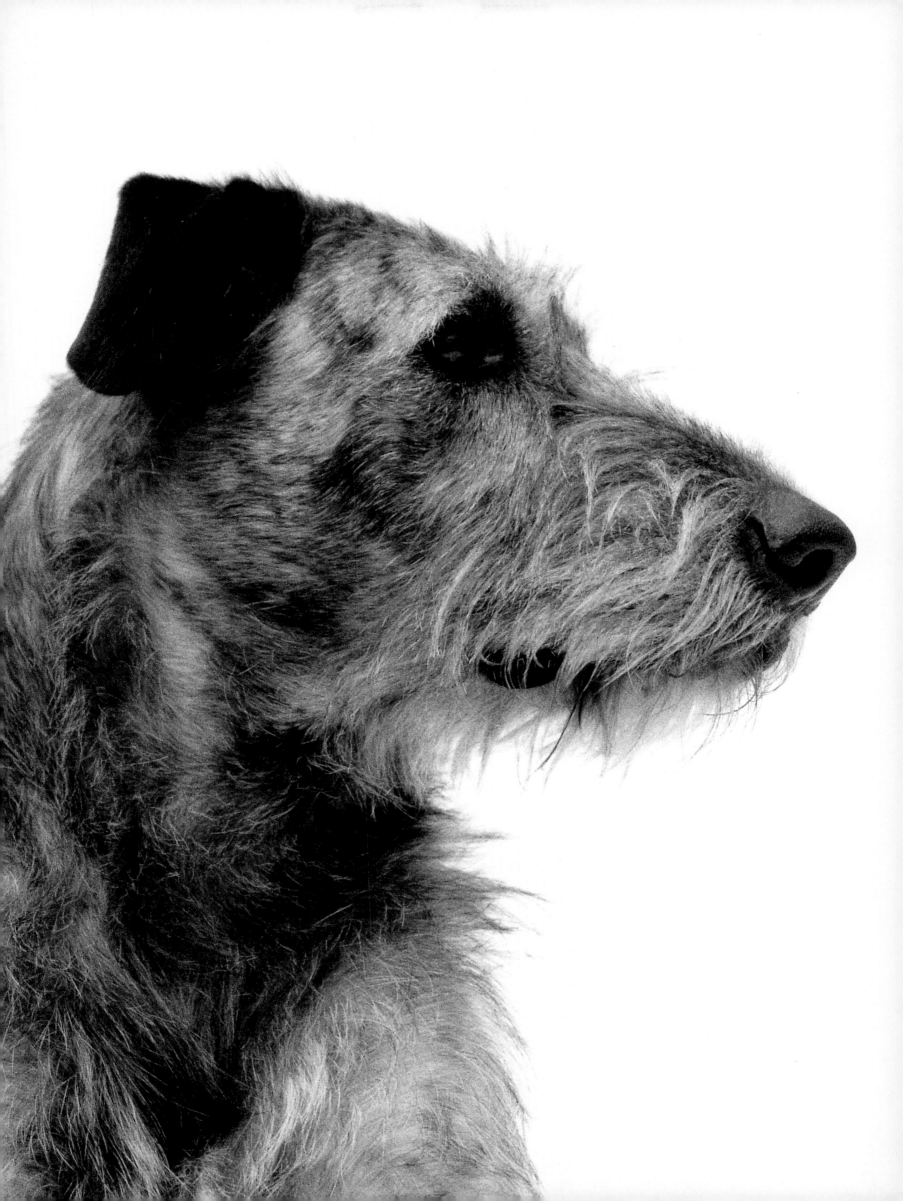

**Irish Wolfhound** *(Canis familiaris)* He is the biggest of them all. That's what children think, anyway, as they strain their necks to look up at him. But not only children. As anyone who has ever lived with an Irish Wolfhound knows: if there are no dogs in heaven, then when I die, I want to go where they've gone.

It's not that he is a lamb, exactly. But in spite of his name, he is still less of a wolf. Perhaps a cross between the two. "Gentle when strok'd, fierce when provoked," say the breeders, and give the future owner a list of warnings, because this dog is not a dog for everyone. It consumes enormous quantities of food, and even a large flat can be too small at times. Books have been written about the training of these animals. The good master looks for a middle path which on the one hand demands complete obedience to the owner, while on the other still allowing the Irish Wolfhound his own personality.

As a companion, he is, according to the Icelandic *Njala Saga* (970-1014 AD) as good as an armed warrior: "And what's more, he has the intelligence of a human-being and will bark at your enemies, but never at your friends. He can read from a man's face whether he means you well or not. And he will sacrifice his life for you."

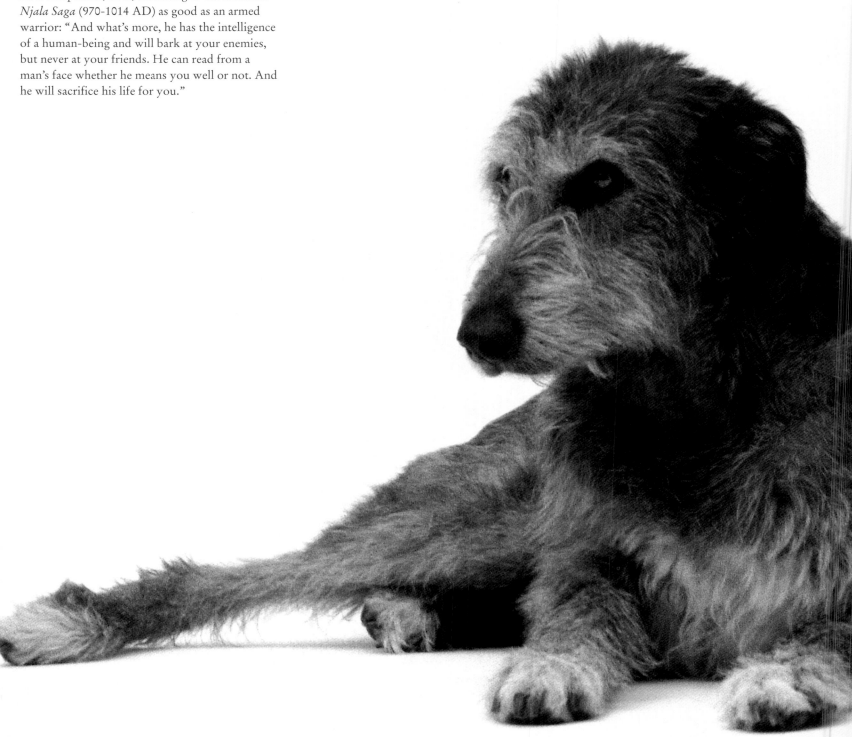

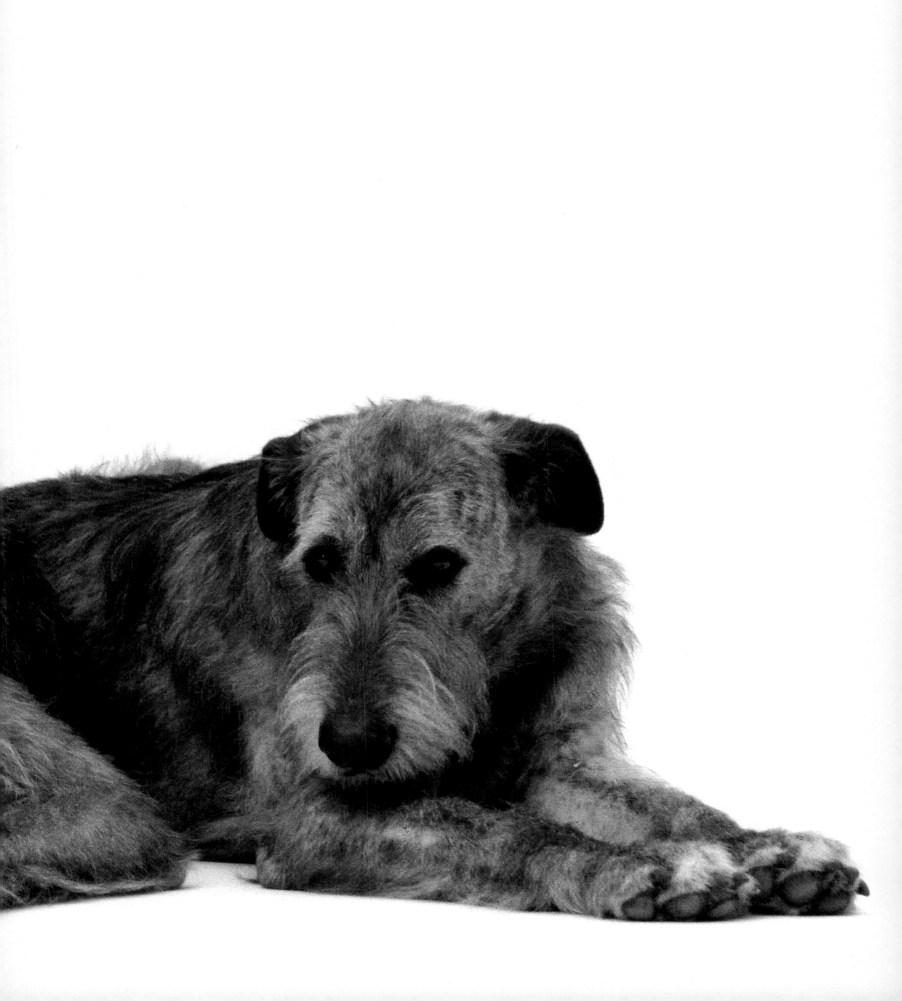

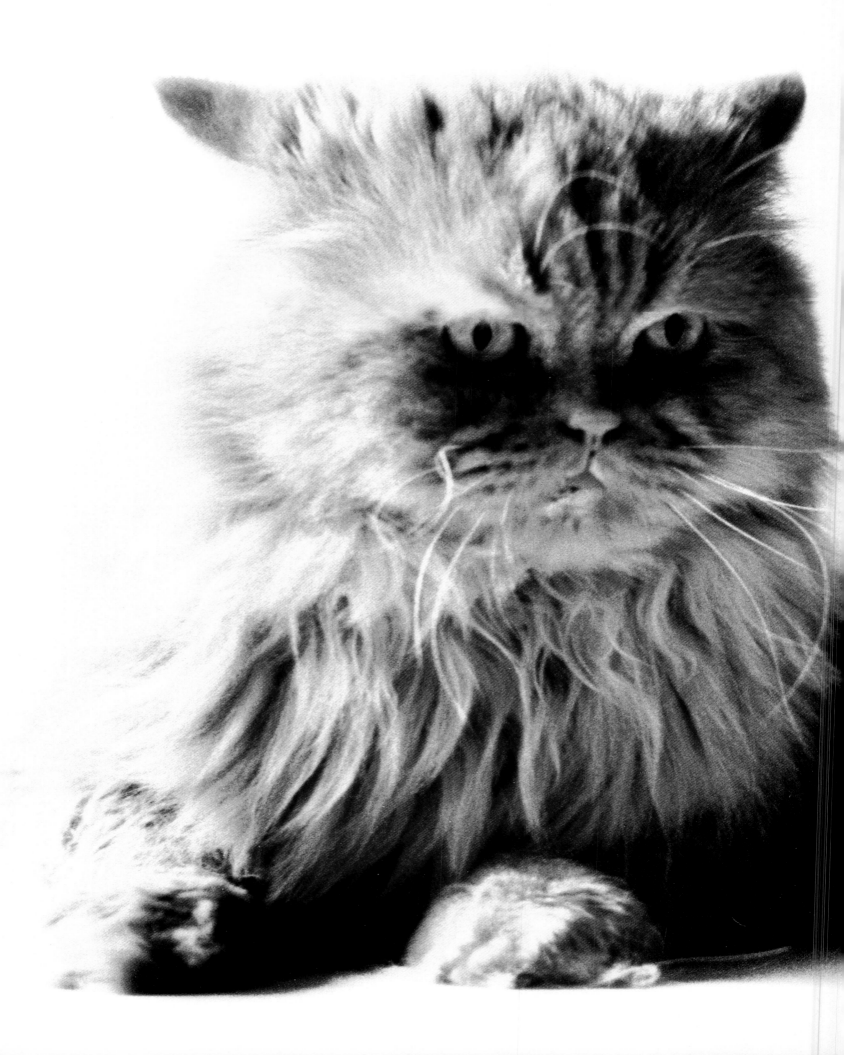

**Persian Cat**  *(Felis catus domestica)*  How proud she looks! The thick coat coddling a soul soft as silk. As a result, this sofa tiger can count on constant care and attention. To be brushed, combed and stroked, and to have a warm place near the hearth is what the Persian cat longs for—and usually gets, not least from Queen Victoria. The bluish coat of that queen's favorite cat still hints at the blue blood flowing through her veins. Needless to say, you can also have your Persian cat in shades of mauve, white, cream, smoke or cameo.

**Maine Coon** *(Felis catus domestica)* Was she carried across the Atlantic by the Vikings, or is she descended from those six long-haired cats that Marie Antoinette sent to Wiscasset before trying to escape from France? Both are possible. One thing is sure, and that is that the "official state cat" of Maine is not a cross between a wild-cat and a raccoon. If need be, she will take a walk on a leash like a dog, but she feels most at ease in a farmyard with children, dogs, and plenty of things to play with.

There she sits, stretches, purrs, or jumps up and walks off who knows where. Like all cats, she has a mind of her own. Many a cat has shot out in front of a car. But don't take it too much to heart,—it was doing what it wanted. And freedom comes at a price. But be sure to put your name down for a new one from your neighbor's litter. Life's fine for each one that manages to survive the first day. You may even get it for a "Thank-you-and-God-bless," unlike this thoroughbred here.

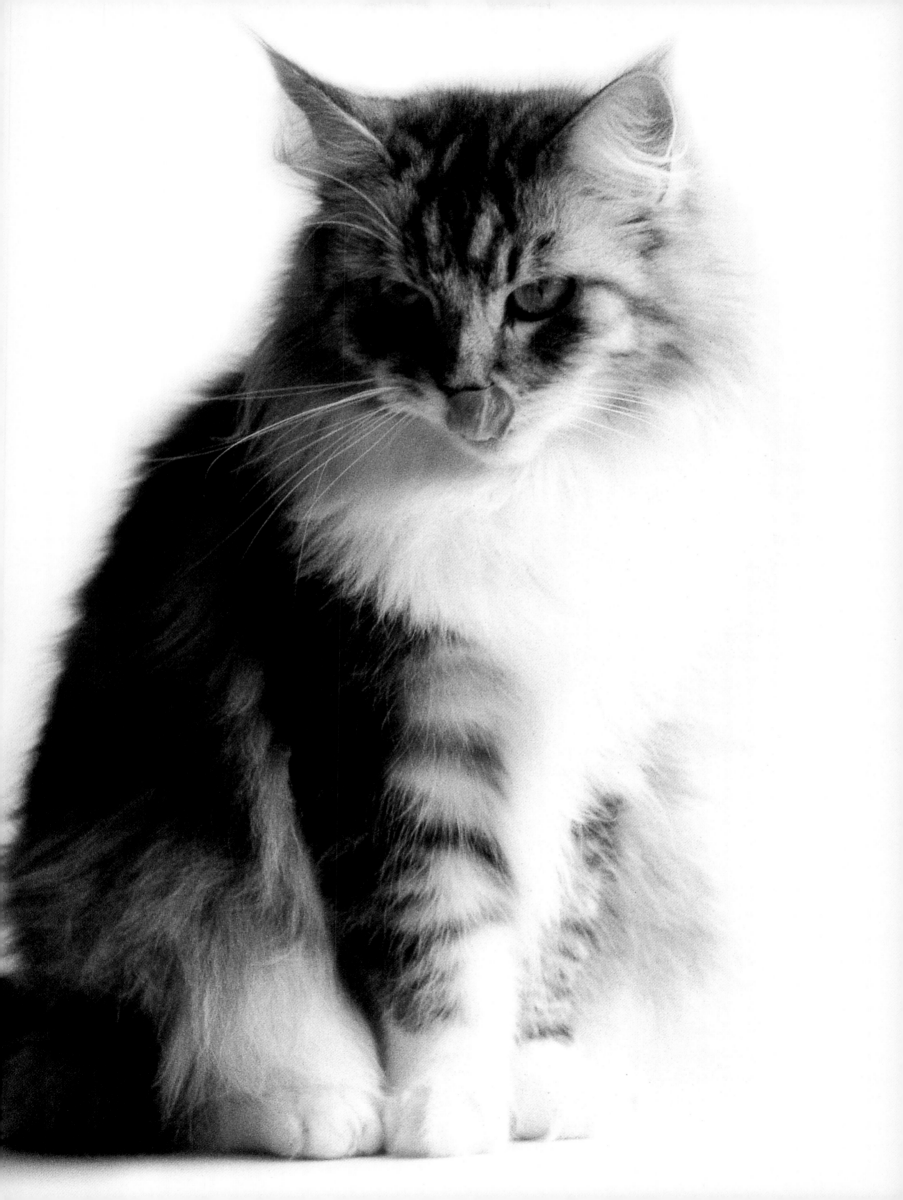

**Each After Its Kind**  *A Moment for Pete Dine and His Photographs of Animals on White*

The German photographer Pete Dine has been photographing animals on white for years, thereby giving rise to a photographic genre. In the early 1980s this earned him an admission ticket to the German Society for Photography (DGPh). Some may call him obsessed. Whatever he does, he does it thoroughly. The result costs time and money, but it also illustrates the important difference between original and copy.

Pete Dine has traveled around half of Europe with an open-air studio in his small truck: to Dublin for the Irish wolfhound, to Hall (Tyrol) for the raven, to the biological institute in Paris for the common hare, to Circus Knie in Zurich for the bears, to the Alpenzoo in Innsbruck for the marmot. This soon adds up to a hundred thousand miles and a few tons of tattered white boxes. For white is white, and the animals standing in front of it are not just any animals.

If at all, then his lens homes in on a magnificent specimen. After all, when Pete Dine takes a photograph of it, it assumes something like an official character: as a measure of things for posterity, and as a contribution to a never ending catalogue of the variety of life on this earth. A. o. W. — the archive abbreviation for "Animals on White" — are visitors' favorites in major zoos, prize-winning champions of important breeds, or fathers and mothers of promising strains. Not all of these animals have come to look the way they do in the wilds. Systematic breeding and in-breeding have made horses and pigs, hens and dogs faster, stronger, smaller, larger, or adapted them to some particular purpose.

One hundred, two hundred? You'd have to count them. But it will never just be some huge number. Photographing animals, be it in an enclosure or in the wilds, requires a lot of patience. And in an enclosure does not mean *through* the fence. Pete Dine gets to close quarters with each animal, until it pays no more attention to itself than a sitter with an experienced portrait photographer.

Somewhere on a parking lot: Pavatex boards are unpacked, the wall and ground covered with concave photographic cardboard, and the whole lot secured with wire netting. Setting up such open-air studios has become a routine matter for Pete Dine. As a rule, they are white and measure roughly 160 square feet; the area can be doubled for larger animals. No problem. But how do you get an animal into this unfamiliar setting without using force? How does he make Ebrahim the donkey climb up a chicken-ladder? Or persuade a stubborn zoo director to throw a net over the finest lynx in the enclosure for a passport photograph? Enthusiasm and perseverance are virtues which photographer

 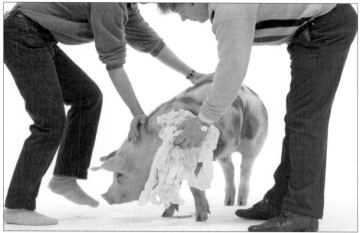

Pete Dine has *en masse* in his bag of tricks. He spent four days in the studio with his lynx in order to get within about 10 inches of his shy partner. It rained for six days before he "bagged" the common hares within a few dry fractions of a second.

The end result is all neat and tidy. But the cock and hens never ceased to wonder about the white earth, scraping and scratching at it as if they wanted to uncover familiar ground, and if that was not possible, then to at least soil it. The pig availed itself of the opportunity to live up to its name, on a great scale. No sooner had the urine and dung been cleared away then it found new spots to leave its mark at. Once its picture had been taken, it grinned up with tilted head, knowingly: the smell would hang around in the pores for weeks. Sometimes things were unexpectedly simple. The English bloodhound of all animals, the kind you find snooping about in any half-way credible detective story, allowed itself be laid out like a Barbie doll. The faithful look in his aristocratic eyes then came quite naturally, and was really genuine.

Every picture in this book has its own story. But the background for them all is the same: white. Real white and daylight, and nothing that might sully the reputation of a photographer of the classical open-air school: flash and montage are out of the question, as is retouching with brush and paint, to say nothing of scissors and adhesive so as to outline the animals post festum. Pete Dine would never have set foot in an enclosure where the bears were wearing muzzles, as the circus dompteur demanded. Getting his model to do its respective thing, the fox to trot in a straight line, painlessly and without medication is a matter of professional honor. And it's also a matter of course for the photographer to wait as long as is necessary until fox and vixen pose, much the way we think they do from seeing specimens.

Pete Dine's pictures have a stamp of quality that dates from pre-Photoshop times: 35 mm and medium format. It is the moment alone that imbues them with credibility, and communicates this to the subject. Pete Dine has respect: for his craft and for the animal. He comes face to face with it, so that it can do likewise. The encounter is not distorted by cuddly looks or butcher's grips. Before us stands an animal in all its animal dignity.

*Markus Mäder*

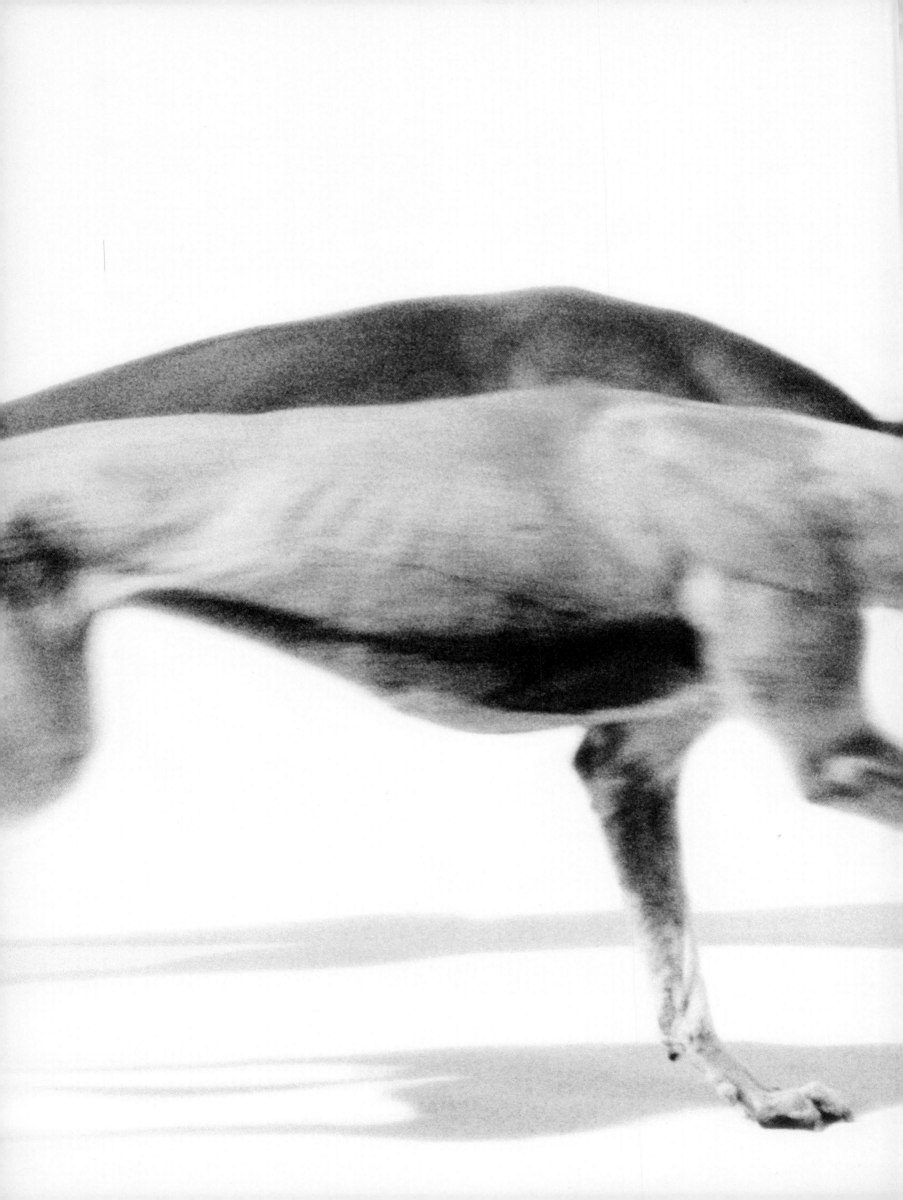

**Pete Dine** was born in Lahr, Germany, in 1943. He studied graphic art and visual communication before moving to London 1971, where he launched a classical career as a freelance feature photographer and photo designer. His spectacular photographs of animals earned him worldwide acclaim. His work has been featured in international publications and hailed by reviewers as a pioneering accomplishment. Numerous awards as well as touring exhibitions in New York, Paris, Tokyo, and Zurich underscore his international reputation. Pete Dine has worked as a writer and film producer since 1991. He lives in Hamburg.

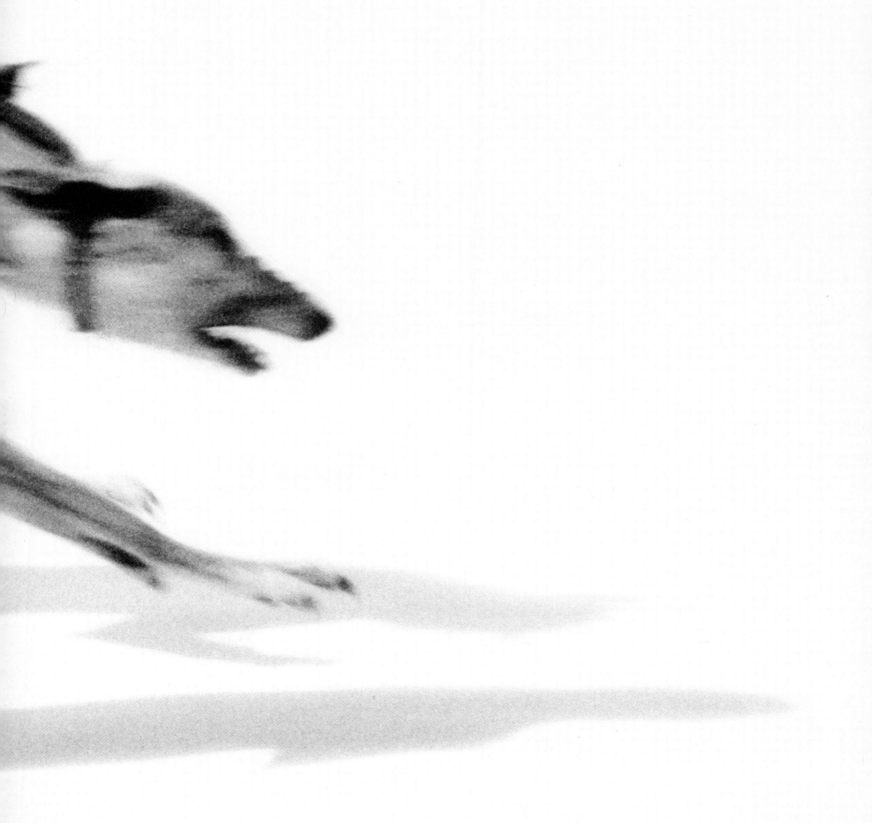

Reproductions copyright by Pete Dine, Hamburg
Text copyright by Markus Mäder

Editorial Direction by Marion Elmer
Translation from the German by Pauline Cumbers and John B. Walmsley
Layout and Typography by Giorgio Chiappa, Zurich
Lithography by pp.digitech ag, Adliswil/Zurich
Printed and bound by Grafiche Duegi, San Martino B.A. (Verona), Italy

ISBN 3-908163-69-2